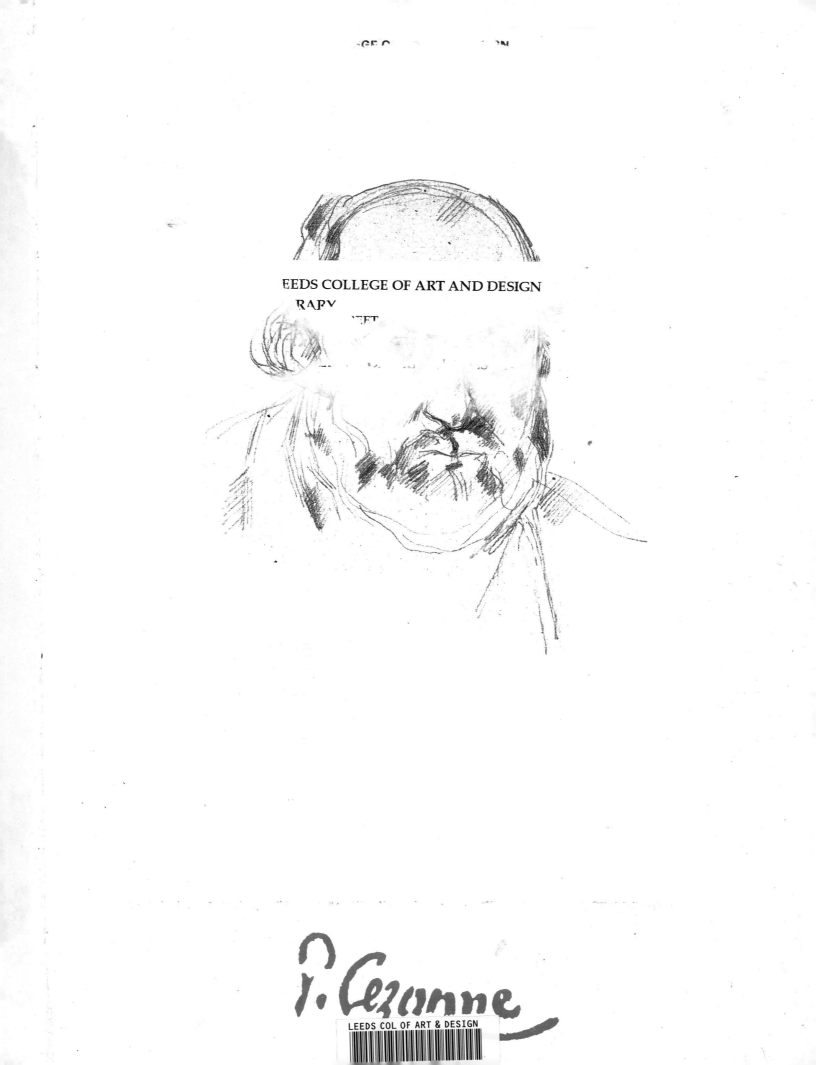

P. Cezanne

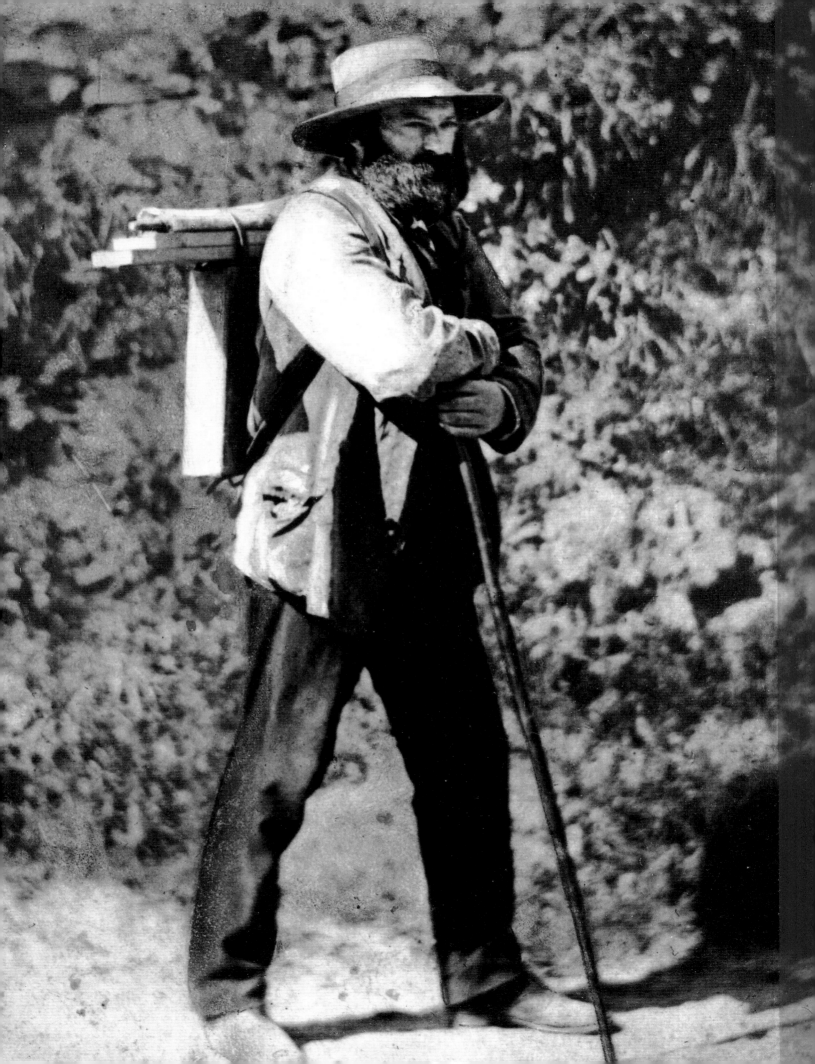

Ulrike Becks-Malorny

PAUL CÉZANNE

1839–1906

Pioneer of modernism

Benedikt Taschen

FRONT COVER:
Pomegranate and Pears on a Plate, 1885–1890 (detail)
Nature morte avec grenade et poires
Oil on canvas, 27 x 36 cm
New York, Stephen Hahn Collection

ILLUSTRATION PAGE 1:
Self-Portrait, 1880 (detail)
Autoportrait
Pencil, 30.4 x 20.5 cm
Basle, Kunstmuseum Basel, Kupferstichkabinett

ILLUSTRATION PAGE 2:
Paul Cézanne on his way to paint near Auvers, c. 1874

BACK COVER:
Paul Cézanne at work, c. 1906

**This book was printed on 100 % chlorine-free bleached
paper in accordance with the TCF standard.**

© 1995 Benedikt Taschen Verlag GmbH
Hohenzollernring 53, D-50672 Köln
Design: Simone Philippi, Cologne
English translation: Phil Goddard in association with
First Edition Translations Ltd., Cambridge, England
Cover: Angelika Muthesius, Cologne

Printed in Germany
ISBN 3-8228-8906-7
GB

Contents

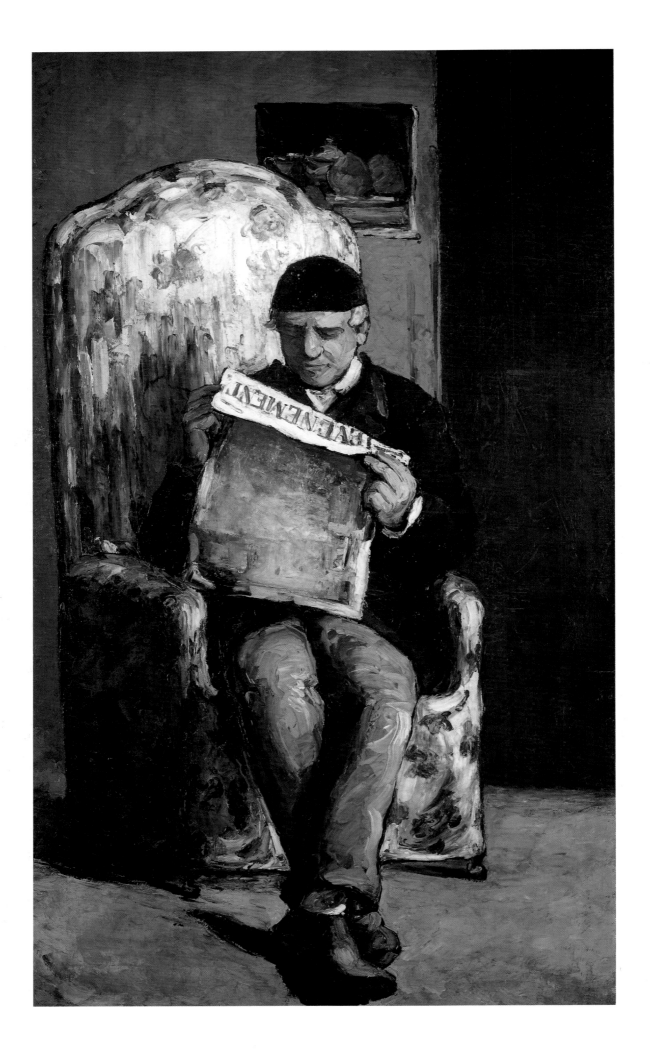

From Banker to Painter

"Paul may have the genius of a great painter, but he will never possess the genius actually to become one. He despairs at even the smallest obstacle."

This harsh criticism by Cézanne's friend of his youth, Emile Zola, remained true of him throughout his life and his career as an artist. Deep inside, he had a belief in his own genius and a determination to pursue his artistic goals, and this belief remained unshaken by frequent periods of self-doubt and despondency. Another of Cézanne's traits was his refusal to make any form of artistic compromise or concession to society, and this often made him appear a strange and eccentric figure.

Cézanne lived only for painting; it was his sole passion in life, and family ties and friendships took second place as far as the "hermit from Aix" was concerned. He saw his surroundings through the eyes of a painter, studying the effects of light and shadow on objects and exploring the relationships between forms and colours. And life was a constant, tormented struggle. Cézanne was a self-taught artist who was rarely satisfied with the results of his labours. Each new picture was a source not so much of pleasure as of pain at his own failure to realize his ideas, so that quite frequently he destroyed a canvas in disappointment and rage at his own inability.

This excitable and impetuous nature was apparent even in Cézanne's youth. He was the least confident and most easily roused of three friends who met at the Collège Bourbon, the long-established humanist college in Aix-en-Provence. The other two were Emile Zola, the future novelist, and Jean Baptiste Baille, who later became an engineer.

The three young men, known at college as the "Inseparables", spent their free time making long excursions in the surrounding area, hunting and fishing and swimming in the river Arc. They held endless debates about art, read Homer and Virgil together, and shared their enthusiasm for the Romantic authors Victor Hugo and Alfred de Musset. They took particular pleasure in writing poetry. Cézanne was an excellent pupil, and was particularly interested in the Classical languages: he often wrote his verses in Latin. "My verse may be purer than yours," Zola admitted to his friend, "but yours is certainly more poetical, more true; you write with the heart; I, with the mind." He acknowledged that Cézanne's poems were more serious, but Cézanne regarded them simply as an agreeable pastime: he had no intention of becoming a serious poet.

Nor did Cézanne show any particular love of painting during this period of his life: he won many prizes at school for above-average performance, but gained only one award for drawing, in the year when he studied at the Ecole spéciale de Dessin in Aix.

The three friends' carefree time together came to an abrupt end in

Sheet of legal texts and various pen-and-ink drawings, c. 1859
Pen-and-ink drawing

In accordance with his father's wishes, Cézanne began studying law. But he did as little studying as possible, instead spending much of his time drawing and writing poems.

ILLUSTRATION PAGE 6:
Louis-Auguste Cézanne, the Artist's Father, Reading "L'Evénement", 1866
Louis-Auguste Cézanne, père de l'artiste, lisant "L'Evénement"
Oil on canvas, 200 x 120 cm
Venturi 91; Washington D.C., National Gallery of Art, Collection of Mr and Mrs Paul Mellon

The portrait of Louis-Auguste Cézanne as an old, serious and dignified man reveals nothing of the artist's humiliating dependence on his father until the latter's death.

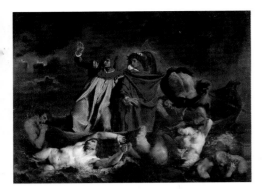

Eugène Delacroix:
The Barque of Dante, 1822
La barque de Dante
Oil on canvas, 189 x 246 cm
Paris, Musée du Louvre

February 1858, when Zola left Aix and went to Paris. As a result of the separation, Cézanne and Zola exchanged frequent letters, swearing undying friendship and recalling the hours they had spent together. Zola greatly missed Cézanne and urged his friend to follow him to Paris and begin a career as a painter. Zola had a very clear idea of how Cézanne might live his daily life in Paris:

"From six to eleven in the morning you could do life painting in a studio school; then you could have your lunch, and from twelve to four in the afternoon you could copy a masterpiece which particularly appealed to you in the Louvre or the Luxembourg Museum. That would mean nine hours of work. I think that would be enough, and with such a programme you are bound to make progress."

Zola was very aware that his friend needed a precise timetable of this kind: he knew that Cézanne was indecisive, lacked confidence, and was unable to stand up to his powerful, authoritarian father. Louis-Auguste Cézanne had worked his way up from a modest position as a hat salesman and exporter to become a successful banker in Aix, and he believed that his son's career lay in banking. He was a pragmatic businessman, obsessed with money and quite unable to conceive that his son might ever want to become an artist.

So Cézanne complied with his father's wishes and, after his school-leaving examinations, signed up for a course in law at the University of Aix-en-Provence. His father wanted him to work in his bank after completing the course.

Cézanne spent two years reluctantly studying law, yet he devoted every minute of his spare time to drawing and writing poetry. In 1859 he began evening classes in life painting at the Ecole spéciale de Dessin in Aix, where he met his former classmates from the Collège Bourbon: Achille Empéraire, Philippe Solari and Numa Coste. At the school, housed in the Musée Granet, Aix's Museum of Fine Art, he won a second prize in the figure study painting course.

Cézanne was increasingly neglecting his law studies and devoting himself to art, and was often to be seen copying paintings in the Musée Granet. But his father still steadfastly refused to allow him to go to Paris. Meanwhile, in the capital, Zola was growing impatient: he knew how indecisive Cézanne was and accused him of not trying hard enough to get what he wanted.

"Is painting only a whim that took possession of you when you were bored one fine day? Is it only a pastime, a subject of conversation, a pretext for not working at law? If this is the case, then I understand your conduct; you are right not to force the issue and make more trouble with your family. But if painting is your vocation – and that is how I have always envisaged it – if you feel capable of achieving something after having worked well at it, then you are an enigma to me, a sphinx, someone indescribably impossible and obscure... Shall I tell you something? But do not get angry: you lack strength of character. You shy away from any form of effort, mental or practical. Your paramount principle is to live and let live and to surrender to the vagaries of time and chance... If I were in your position, I would make a decision and stake your all, instead of continuing to drift back and forth undecided between two such different places as the studio and the courtroom. It pains me that you suffer from this uncertainty, and I believe that would be another reason to give your all. Either one or the other – either become a proper lawyer, or become a serious painter, but do not become an undecided creature in a paint-spattered robe."

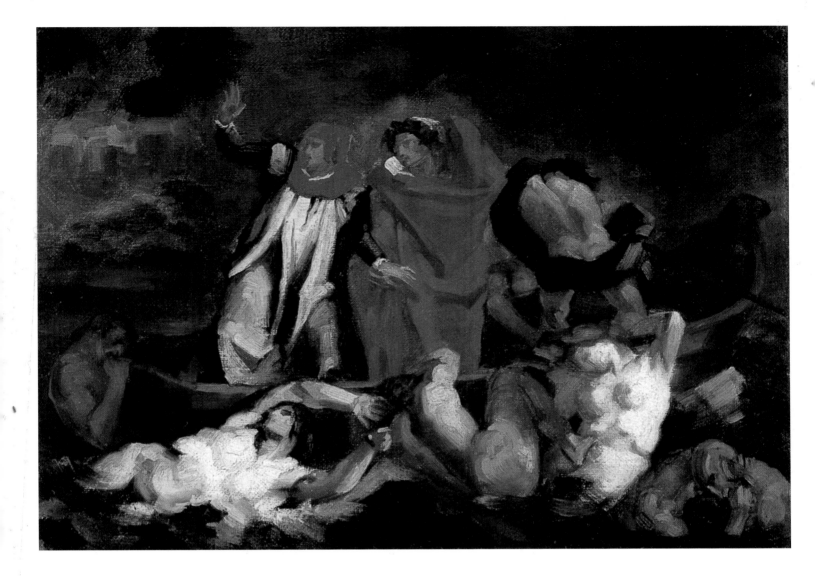

Life in the Cézanne household had become increasingly intolerable. In 1859, the family had bought Jas de Bouffan, the decaying former summer residence of the Governor of Provence. Paul became increasingly withdrawn, and eventually his father relented and allowed his son to leave Aix. Cézanne went to Paris in 1861, where Zola eagerly awaited him.

But his great hopes of Paris were not fulfilled. He made frequent visits to the Louvre, where he copied works by Titian, Rubens and Michelangelo. He met Zola and regularly drew in the Académie Suisse, a studio where young art students could work from models for ten francs a month. It was there that he met Camille Pissarro, who was nine years older than himself and with whom he later painted from nature, as well as Armand Guillaumin, Claude Monet and Auguste Renoir. He also met Achille Empéraire, whom he knew from the Aix Drawing School.

Nonetheless Cézanne was not happy in Paris: he still felt an outsider, and before long he was planning to leave. "I am wasting my time in every respect," he complained to a friend in Aix. "Just don't go imagining that I shall become a Parisian..."

Zola was disappointed by Cézanne's lack of drive, and tried to inveigle his friend into staying by asking him to paint his portrait. Cézanne did so, but was so disappointed by the result that he destroyed it. In September 1861, after his application to join the Ecole des Beaux-Arts had been rejected, he returned to Aix, deeply disappointed.

"The Barque of Dante", after Delacroix, 1870–1873
"La barque de Dante", d'après Delacroix
Oil on canvas, 25 x 33 cm
Venturi 125; Cambridge (MA), private collection

Cézanne painted a total of six copies after works by the Romantic artist he so greatly admired. It was from Delacroix that he learned to use colour to express the inner relationships between figures and objects.

Spring, 1860–1862
Le printemps
Oil on canvas, 314 x 97 cm
Venturi 4; Paris, Musée de la ville de Paris,
Petit Palais

Summer, c. 1860–1862
L'été
Oil on canvas, 314 x 109 cm
Venturi 5; Paris, Musée de la ville de Paris,
Petit Palais

The first pictures to be painted were probably
the inner two, *Summer* and *Winter*, since the
artist would appear to be less at home with
the new technique of painting in these two
works. The motifs on the outer walls, *Spring*
and *Autumn*, are more skilfully painted.

The salon of the Jas de Bouffan, Aix-en-
Provence, with Cézanne's murals, c. 1900
Photograph
Paris, Bibliothèque Nationale de France

There he reluctantly returned to work in his father's bank, but he also set
up his own studio in Jas de Bouffan. No sooner was he back at his desk
than he was longing to return to Paris. In the bank's account book, he wrote:
"The banker Cézanne does not see without fear / Behind his desk a painter
appear." His father realized that Paul would never take over from him at
the bank and allowed him to travel to Paris a second time, this time on con-
dition that he study properly at the Ecole des Beaux-Arts. He gave his son
a monthly allowance of 125 francs to enable him to work without having
to earn a living.

Back in Paris, Cézanne was again turned down by the Ecole des Beaux-
Arts on the grounds that his paintings were clumsy and unconventional, a
long way from what was generally regarded as art. Cézanne did not take
his application any further, for he had had enough of the Ecole des Beaux-

Winter, c. 1860–1862
L'hiver
Oil on canvas, 314 x 104 cm
Venturi 7; Paris, Musée de la ville de Paris,
Petit Palais

Cézanne signed all four paintings INGRES.
The picture of *Winter* also bears the year,
1811, thereby providing an ironic reference to
the unpopular painter and his masterpiece,
Jupiter and Thetis, which was the best-known
painting in the Aix Museum.

Autumn, c. 1860–1862
L'automne
Oil on canvas, 314 x 104 cm
Venturi 6; Paris, Musée de la ville de Paris,
Petit Palais

In 1859 Cézanne's father bought the Jas de
Bouffan ("House of the Wind"), the former
summer residence of the Governor of Provence,
to the west of Aix. Some of the rooms were
in such poor condition that they were unin-
habitable and remained locked up. The follow-
ing year Cézanne, who was spending more
and more of his time painting, was given
permission by his father to paint a series of
large murals in the salon.

Arts, with its rigid hierarchies and hidebound attitudes. Instead, he continued
his studies at the Académie Suisse, which he now regularly attended.

The Ecole des Beaux-Arts was the pillar of the French artistic establish-
ment at this time. It was impossible to imagine a successful career as an
artist without it, and particularly without its associated annual exhibition,
the Salon. Its high priest was the Classicist Jean Auguste Dominique Ingres
(1780–1867), and his serried ranks of pupils obeyed his dictum that line
was more important than colour: the main aim was to base work in paint
on very detailed drawing and careful outlining. Paint itself was used simply
to provide coloration. The canvases were dominated by historical and mytho-
logical scenes; using landscape as a subject for paintings in its own right
was totally out of the question.

In the second quarter of the century, Eugène Delacroix (1798–1863) led

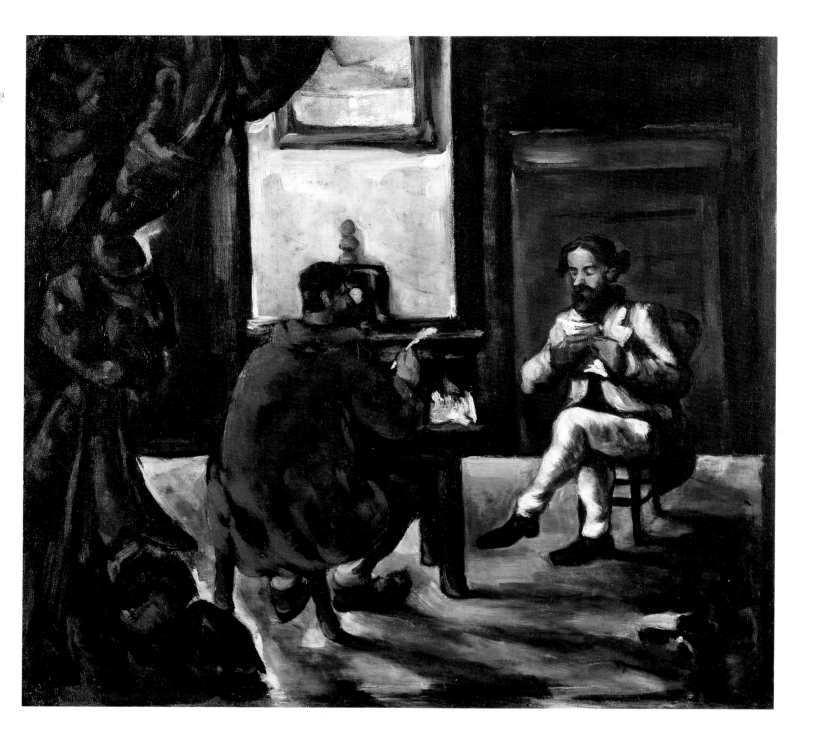

Paul Alexis Reading to Zola, c. 1869–1870
La lecture de Paul Alexis chez Zola
Oil on canvas, 52 x 56 cm
Venturi 118; private collection

This painting, built up using effective light-dark and red-green contrasts, shows Cézanne's friend from his youth, Emile Zola, author of the novel cycle *Les Rougon-Macquart*. The other figure is Zola's secretary Paul Alexis, a journalist, writer and friend of Cézanne from his time in Aix.

a Romantic backlash against this dictatorship of the line. The Romantics regarded colour as more important than drawing, and the artist's individual sensitivities as more important than artistic convention. As a result, the French art world split into two camps. The battle between Ingres and Delacroix, Classicism and Romanticism, line and colour was a major topic of discussion and a popular subject for caricaturists.

Alongside these currents, with their largely aristocratic and upper middle-class roots, a new movement grew up using raw, unadorned real life as its subject matter. It was founded by Gustave Courbet (1819–1877), whose adherents called themselves the "Realists"; their battlecry was: "Let us be true, even if we are ugly!" Influenced by the industrial and political revolutions of the day, the artists began using subjects from contemporary everyday life, and Courbet called on them to paint ordinary scenes and figures, to "bring art into contact with the common people".

But the final break with historical painting was made by Edouard Manet (1832–1883), whose painterly version of realism, with its bright, clear-edged colours, was admired by the open-air painters. Manet was interested not in analytical observation but in reproducing his own subjective perceptions, freeing the subject from any burden of symbolic content.

The conflict between these different currents was the subject of much impassioned debate in cafés and studios. The artists of the Atelier Suisse strongly advocated Realism and discussed the paintings of Manet, while, in the Academy's narrow-minded Ecole des Beaux-Arts, artists adhered firmly to the tenets of Ingres. The middle-class public still preferred large-scale historical paintings, allegorical scenes and insipid genre paintings.

The most important forum for artists was the annual Salon, which was largely the arbiter of public tastes. The Academy's members followed strict criteria in selecting the entries: there was no place for originality, innovation or anything which differed from the Academy style. But it was every artist's greatest desire to be in the Salon, as this was the only way of exhibiting work in public, gaining a reputation and selling pictures.

When a particularly large number of works were turned down at the 1863 Salon, there were massive protests from artists, with the result that Napoleon III allowed a parallel exhibition to be set up for works which had been rejected. This "Salon des Refusés" was intended to give the public a chance to form their own views about the works which had been turned down by the Academy.

But people were not at all used to the idea of making up their own minds about contemporary art, and the exhibition was ridiculed. The criticism centred on Manet's *Le déjeuner sur l'herbe* (1863, ill. p. 30), which Napoleon III described as "indecent". The strikingly relaxed display of female nudity in Manet's painting, set in a realistic landscape rather than the intimate atmosphere of a boudoir, scandalized the middle-class public. So did the simplified, rapid style of painting, with its renunciation of any form of illusion: as Zola wrote, "One is not accustomed to seeing such simple and sincere renditions of reality."

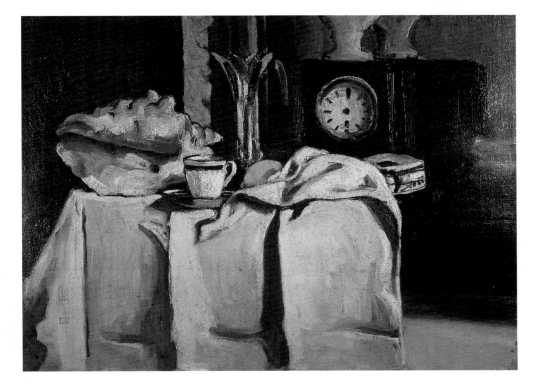

The Black Clock, 1869–1871
La pendule noire
Oil on canvas, 54 x 73 cm
Venturi 69; private collection

Every object in this painting, with its rhythmic horizontal and vertical construction, forms an integral part of the rigorous structure and yet also exists in its own right. There is a stark contrast between the organic opening of the seashell and the cold marble of the clock.

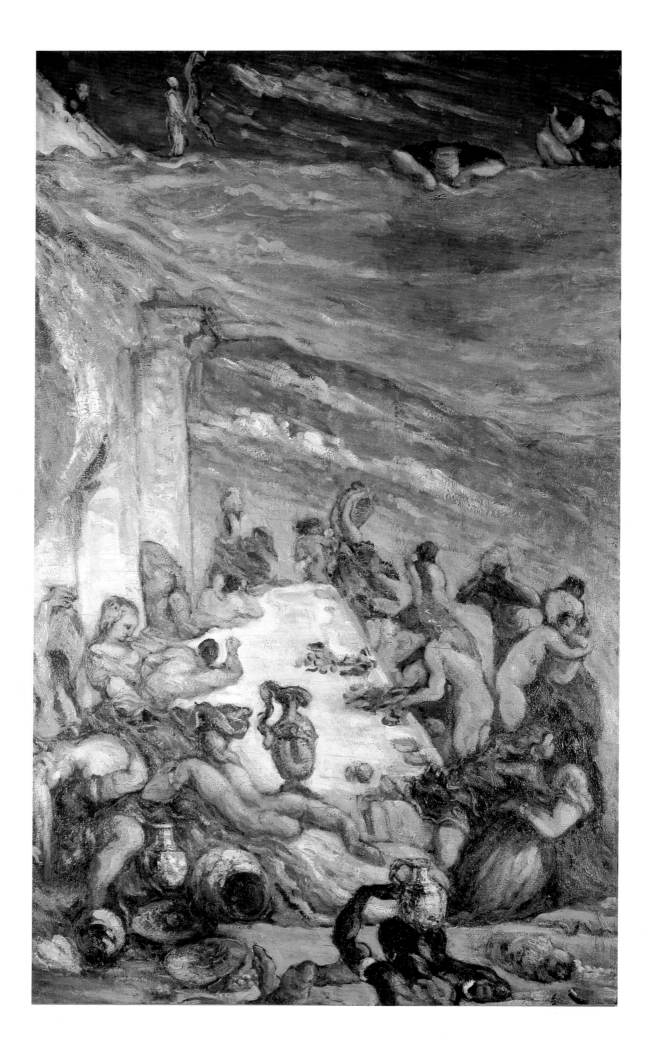

Studies for **The Orgy**, 1864–1868
Groupes en mouvement
Chalk and ink drawing
Chappuis 135 and 136; Basle, Kunstmuseum
Basel, Kupferstichkabinett

The Orgy, or the Banquet, c. 1867
L'orgie ou le banquet
Coloured chalk, pencil, watercolour and
gouache on cardboard, 32.4 x 23.1 cm
Stuttgart, private collection

Cézanne repeatedly depicted the themes of
the war between the sexes and of seduction.
The grainy colour of this particular painting
is reminiscent of a Venetian mural.

The *succès de scandale* of the "Salon des Refusés" drew young painters
closer together. The Café Guerbois in the Batignolles district became a
regular meeting-place for Manet and his circle, and Cézanne often went
there. But he remained an outsider to this environment. With his strong
Provençal accent, dishevelled clothing, rustic appearance and distrustful
personality, he did not fit in to the Paris art world, and he was mocked as
an eccentric.

Cézanne never stayed in one place for very long. Even in Paris he
frequently moved apartments and could rarely tolerate the hubbub of the
city for more than six months at a time, retreating instead to the Provençal
seclusion of Jas de Bouffan. Between 1863 and 1870 he regularly spent
part of the year in Aix, where he painted numerous portraits of his uncle
Dominique, who willingly sat as his model. It was there, as well, that he
painted his portrait of *Louis-Auguste Cézanne, the Artist's Father, Reading
"L'Evénement"* (ill. p. 6). He showed his father immersed in a liberal news-

ILLUSTRATION PAGE 14:
The Orgy, 1864–1868
L'orgie
Oil on canvas, 130 x 81 cm
Venturi 92; private collection

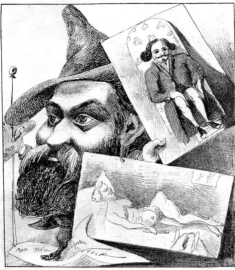

Incident du 20 mars au Palais de l'Industrie ou un succès d'antichambre avant l'ouverture du Salon

This caricature shows Cézanne with the two paintings that were rejected by the 1870 Salon.

paper of the kind which he would not normally have dreamed of reading; Louis-Auguste normally read the republican paper, *Le Siècle*. In fact *L'Evénement* was the publication in which Zola regularly wrote articles defending Manet and his circle of young artists as well as condemnations of the jury at the 1866 Salon. On the wall behind his father (ill. p. 6) is a still life by Cézanne, looking like a normal part of the furnishings of the house. This severe portrait, painted with a palette knife, flies in the face of reality by depicting Louis-Auguste Cézanne as a benign patriarch. Could this be an embodiment of Cézanne's wish for a harmonious relationship with his father, a relationship respectful rather than patronizing?

A few years later, Cézanne painted the *Portrait of Achille Empéraire* (1867–1870, ill. p. 17), his fellow-student at the Atelier Suisse, whom he greatly respected. Empéraire lived in extreme poverty; a hunch-backed dwarf, he never achieved recognition during his lifetime. The portraits of his father and Empéraire, each sitting in the same chair, were painted only a few years apart. A comparison shows how much Cézanne's style had changed during this short period: the flowery seat cover in the portrait of his father is painted in an Impressionist, illusionist manner, but the decoration on Empéraire's chair is shown very precisely, almost schematically. The strong frontal approach, the evenly lit picture with very few areas of shadow and the bold use of colour give the subject a monumental dignity. The painting grants this humble artist the recognition which so obstinately eluded him during his lifetime.

Cézanne submitted this painting and a female nude, which has since been lost, to the 1870 Salon. As usual, he was rejected. An article on the Salon by a critic named Stock includes a caricature of Cézanne and the two rejected paintings (ill. p. 16, top left). Cézanne is portrayed as an eccentric-looking figure with a walrus moustache, and his two paintings are distorted and grotesque. Cézanne defiantly defended himself:

"Yes, my dear Mr Stock, I paint how I see, how I feel – and I have very strong feelings – you also feel and see as I do, but you do not take risks... You paint Salon paintings... I take risks, Mr Stock, I take risks... I have the courage to stand by my opinions... and... he who laughs last, laughs longest."

ILLUSTRATION PAGE 17:
Portrait of Achille Empéraire, 1867–1870
Portrait d'Achille Empéraire
Oil on canvas, 200 x 122 cm
Venturi 88; Paris, Musée d'Orsay

"A dwarf, but with a magnificent Van Dyck-like cavalier's head, a flaming soul, nerves of steel, iron pride in a misshapen body, the flame of genius in a crooked frame, half Don Quixote, half Prometheus" (Joachim Gasquet).
Cézanne's portrait pays homage to the friend he respected so greatly, showing him in a combination of dignified melancholy and pride.

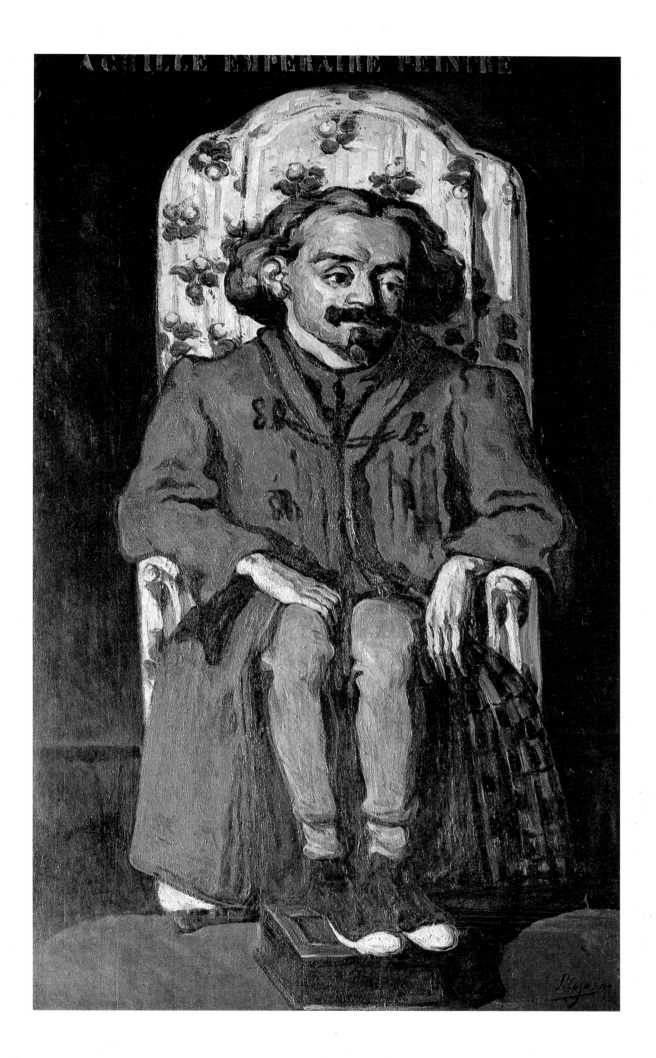

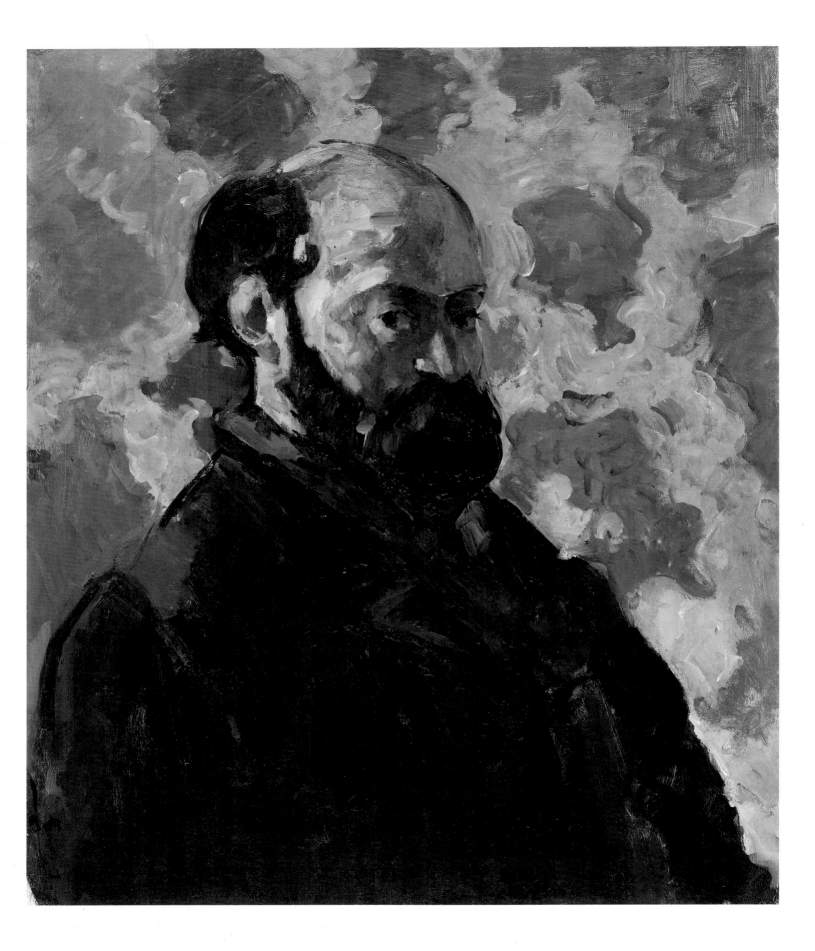

Cézanne and the Impressionists

When the Franco-Prussian War broke out in the summer of 1870, Cézanne moved from Aix to the fishing village of L'Estaque, near Marseilles, thus avoiding being called up. For the past year, he had been living with a woman eleven years younger than himself, Hortense Fiquet, a bookbinder whom he had met as a model in Paris. But this relationship did not bring him the freedom from loneliness and sexual frustration which he sought. Cézanne was shy in the presence of women and had a panic-stricken fear of physical contact, which he admitted was rooted in a childhood trauma: when he was at school one day, he had been standing on a staircase when another child suddenly kicked him violently from behind. He also distrusted other people, and none of these traits changed as a result of living with Hortense.

Cézanne kept this relationship secret from his father for eight years, afraid that his monthly allowance might be cut off. It was not until 1886 that he set the seal on his relationship with Hortense by marrying her.

Hortense did not share Cézanne's passion for painting and literature, and she preferred the bright lights of Paris to the solitude of the Provençal countryside. But she seems to have possessed huge reserves of patience and posed for the artist in endless sittings. He painted over forty portraits of her, mostly showing her as a severe and reserved-looking woman with hard, angular features, such as *Madame Cézanne in a Red Armchair* (c. 1877, ill. p. 41) and *Madame Cézanne in Blue* (1885–1887, ill. p. 53).

In L'Estaque, the war seemed far away, and Cézanne, who had never been interested in the machinations of politics, remained wholly oblivious to it. He ignored his call-up papers and concentrated entirely on painting. He later said to Ambroise Vollard: "During the war, I worked a great deal from nature in L'Estaque. Apart from that, I cannot tell you of a single unusual event that occurred in 1870–1871. I divided my time between the countryside and the studio."

Cézanne became intoxicated with the rocky Mediterranean landscape, and painted for all he was worth. He worked outdoors and made great efforts to depict only what he saw with his own eyes. The fishing village of L'Estaque, with its greyish-green, mirror-like bay, the rows of houses and steep streets, the rugged white limestone crags and emerald-green pines, provided him with plenty of new subjects for his paintings.

Cézanne showed no reaction to the proclamation of the Republic. A new town council was formed in Aix and made him a committee member of the drawing school and the museum, a post in which he could have exerted an influence on the museum's policy. Like his father, who was elected to the finance committee but never attended a council meeting, Cézanne showed no interest in the public affairs of his home town. He remained in the

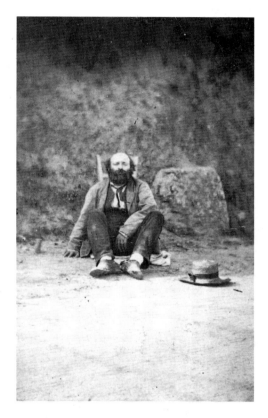

Paul Cézanne, c. 1874
Photograph

ILLUSTRATION PAGE 18:
Self-Portrait on Rose Background,
1875–1877
Portrait de l'artiste
Oil on canvas, 65 x 54 cm
Venturi 286; Basle,
Galerie Beyeler, private collection

Cézanne depicts himself here as an extremely withdrawn, distrustful personality, with that "expression of uncontrolled astonishment... in which children and country-dwellers sometimes lose themselves". Based on this self-portrait, Rilke described the artist he admired so much as "humble and colossal", "meek and larger than life".

The Cutting c. 1870
La tranchée
Pencil and Indian ink on paper, 14 x 23 cm
Whereabouts unknown

This is a study for Cézanne's painting *The Cutting,* but does not include Mont Sainte-Victoire.

fishing village and devoted himself to painting its magnificent landscape. After the winter of 1870–1871, which was unusually cold and snowy by Provençal standards, he painted *Snow Thaw in L'Estaqu*e (c. 1870, ill. p. 23).

This painting is still largely dominated by the sombre colours, stark contrasts and dramatic exuberance of Cézanne's early work, but the subject is no longer a work of the imagination: it is painted from life. The steep diagonals of the snow-covered slope and the roof of the house are real, as are the tops of the stone pines bent by the Mistral and the threatening sky. But this drama of nature in the raw also reflects the artist's inner turmoil. Cézanne's passionate temperament was still causing him problems, and his technique did not enable him to depict what he saw in nature with sufficient detachment and rigour, and at the same time allow his own perceptions to resonate in his work.

Cézanne spent part of the war in L'Estaque with Hortense and part of it in his parents' house in Aix without her. It was there, near Jas de Bouffan, that he painted a prosaic southern French landscape, *The Cutting* (1867–1870, ill. p. 21). The bright colours and simple, unsentimental motif already show the influence of the bright colours of the Impressionists, but his style of painting is completely different from theirs. Cézanne has used broad, decisive expanses of colour which give the landscape considerable strength and formal rigour. Objects retain their own materiality: sand, earth and rocks are not hinted at, but are presented to us as direct, banal, unadorned reality. The almost parallel arrangement of the individual planes leads the eye to the centre of the picture, where the railway cutting slices into the picture like a gaping wound.

Cézanne often voiced his attitude to the changes which technological progress had wrought in the landscape and in people. "The town of Aix has been ruined by the Chief Engineer of Roads. You will have to hurry if you want to see anything. Everything is disappearing", he remarked to his fellow-painter Emile Bernard. And he told the archaeologist Jules Borély: "Above all other things, I love the look of people who have grown old, but have not departed from their traditional ways in accepting the laws of the time. I hate the effects these laws are having."

In view of this assessment, the bald, emotionless painting of the railway cutting with its mountain, fields and hills can be seen as an invocation of the eternal and constant dominance of the powers of nature. These powers provided a counterpart to the changes wrought by time. This painting also marks the debut of Cézanne's much-loved mountain, Mont Sainte-Victoire, a massive, almost surreal prominence with its crystalline structure providing a symbol of timelessness and permanence.

After the war ended, Cézanne and Hortense returned to Paris, where their son Paul was born in January 1872. Cézanne was discontented and angry with himself and the world: he had a family to feed, and was more tied down than ever before. His friend Achille Empéraire asked to stay with him for a few months, but left Cézanne's apartment in the Rue Jussieu after only a short time:

"... it was unavoidable; otherwise I would not have escaped the fate of the others. I found him here, abandoned by everyone. He hasn't got a single intelligent or close friend any more. Zola, Solari and all the others are no longer spoken about. He is the strangest chap one can imagine ..."

During this despondent period, Cézanne took up Camille Pissarro's invitation to visit him in Pontoise. There, in the Oise valley, where Charles François Daubigny had also settled, there were countless subjects for landscape painters. Cézanne was delighted at the invitation, since he still

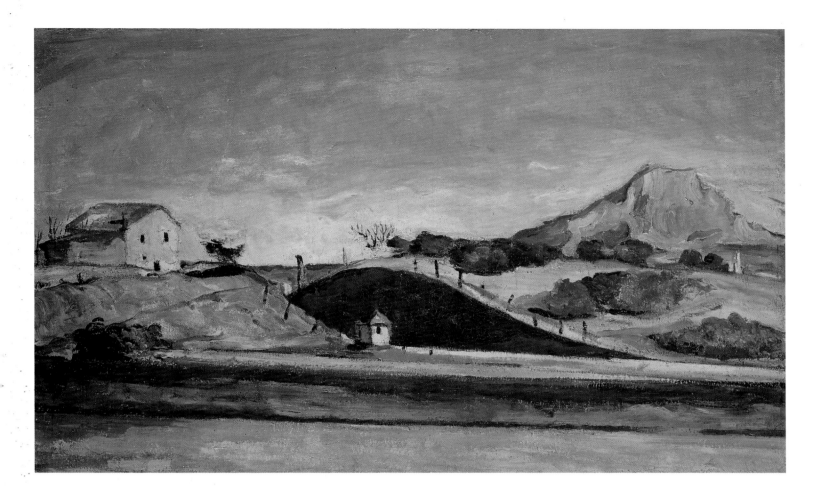

lacked the experience to develop the individual technique which he needed. This he hoped to learn from Pissarro.

The fact that the shy and sensitive Cézanne was able to put himself in someone else's hands probably reflected Pissarro's sympathetic and tolerant personality. He had a patient and unassuming nature which made him a born teacher. "Pissarro was like a father to me... almost like the good God," Cézanne later said. His friend and mentor was nine years older than he was, and was a firm believer in Cézanne's exceptional talent.

The first thing Pissarro did was to encourage him to banish dark colours from his palette. He himself had removed black, ochre and sienna from the range of colours he used. "Only paint with the three primary colours (red, yellow, blue) and their derivatives," he advised Cézanne. He showed him how to build up a picture from light-dark contrasts and, most importantly, encouraged him to observe nature conscientiously, transferring onto canvas only what he saw, without interpreting it or adding anything from his own imagination. He believed that the artist should be nothing more than an alert, conscientious observer of reality.

Pissarro also advised Cézanne not to use lines to outline the forms of his motifs. Rather, objects should be built up by gradations of tonal value.

"Do not work bit by bit," he advised Cézanne, "apply colour everywhere and observe the tonal values closely in relation to the surroundings. Paint with small brushstrokes and try to record your observations immediately. The eye must not concentrate on a specific point, but should absorb everything and in doing so note the reflections of colours on their surroundings. Work on the sky, the water, the branches and the earth simultaneously, and keep on improving what you do until the whole thing works. Cover the whole canvas in the first sitting, and work until there is nothing more to

The Cutting, 1867–1870
La tranchée avec la Montagne Sainte-Victoire
Oil on canvas, 80 x 129 cm
Venturi 50; Munich, Neue Pinakothek

Cézanne painted this ordinary-looking landscape near Aix in the bright colours of the Impressionists, but without creating atmosphere by resolving the forms. This is the first of his paintings to feature the mountain he loved so much, Mont Sainte-Victoire.

21

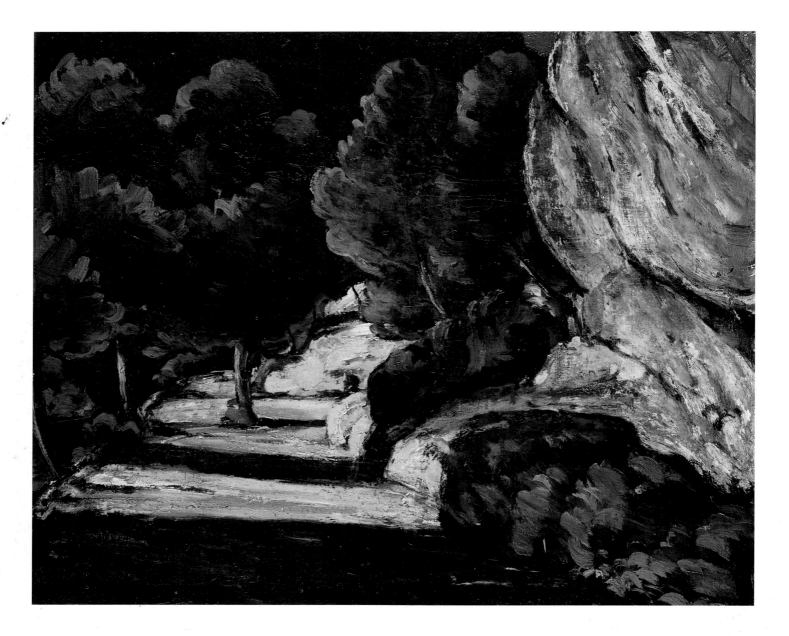

Landscape, 1870–1871
Paysage
Oil on canvas, 53.8 x 64.9 cm
Not in Venturi; Frankfurt/Main, Städtische Galerie im Städelschen
Kunstinstitut

Unlike *Snow Thaw in L'Estaque*, Cézanne has used an unspectacular natural
formation as his motif: a forest path on a rocky pine-covered hillside. However,
the contrasting colours and interplay of light and shade make this simple
subject very expressive, and its effect is due to the fact that Cézanne has
painted reality as he sees it, without embellishment.

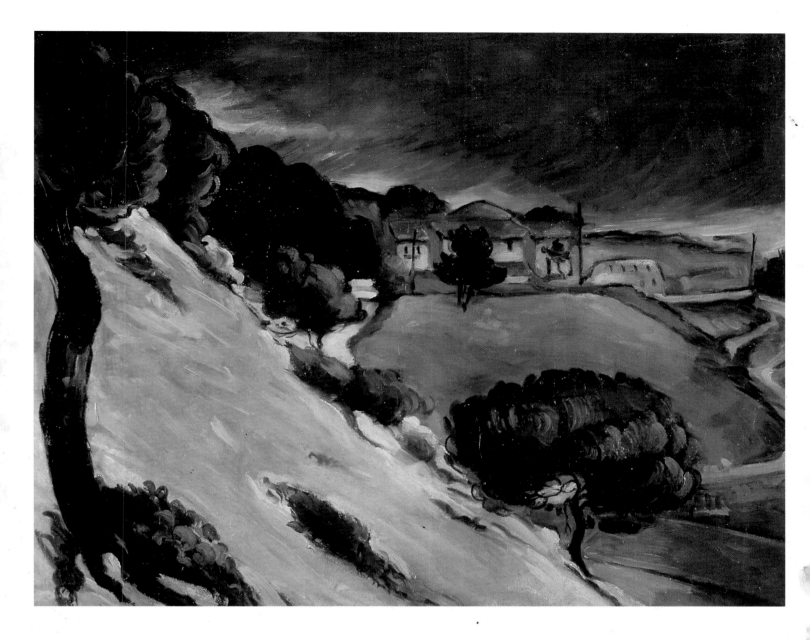

Snow Thaw in L'Estaque, c. 1870
La neige fondue à l'Estaque
Oil on canvas, 73 x 92 cm
Venturi 51; private collection

The expressive drama of this landscape is reminiscent of the highly
emotional figure paintings of Cézanne's early period.

Paul Cézanne (centre) with Camille Pissarro
(right) near Auvers, c. 1874
Photograph

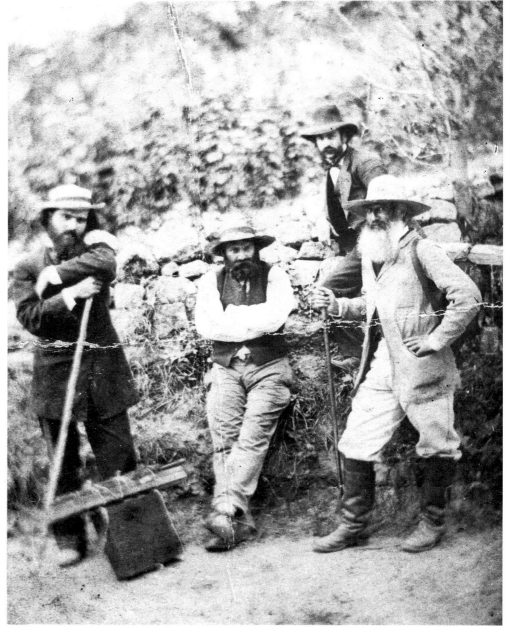

Camille Pissarro:
Paul Cézanne, 1874
Etching, 27 x 21 cm
Paris, Bibliothèque Nationale de France

ILLUSTRATION PAGE 25:
The House of Dr Gachet in Auvers, c. 1873
La maison de M. Gachet à Auvers
Oil on canvas, 46 x 38 cm
Venturi 145; Paris, Musée d'Orsay

From late 1872 to the spring of 1874,
Cézanne lived in Dr Paul Gachet's house in
Auvers-sur-Oise. Gachet was the first person
to buy pictures from him.

add. Observe the aerial perspective closely from the foreground to the
horizon, the reflection of the sky and the foliage.

Do not be afraid of applying strong colour; gradually refine your work.
Do not follow rules and principles, but paint what you see and feel. Paint
boldly and without hesitation, because it is important to get your first im-
pressions down. And do not be shy of nature! You must be bold, even at the
risk of going wrong and making mistakes. There is only one teacher: nature..."

The two friends often chose the same subjects, painting side by side.
"We were always together," Pissarro reported later, "but each of us kept
the only thing which matters: our own perceptions."

Cézanne even went so far as to make a faithful copy of a painting by
Pissarro to familiarize himself with his friend's technique. He did not
always find it easy to paint short, patient brushstrokes side by side on the
canvas. But he felt that Impressionist techniques brought him nearer to his
aim and helped rein in his wayward temperament. Cézanne's short, relaxed
and free brushstrokes, resembling those of the Impressionists, gradually

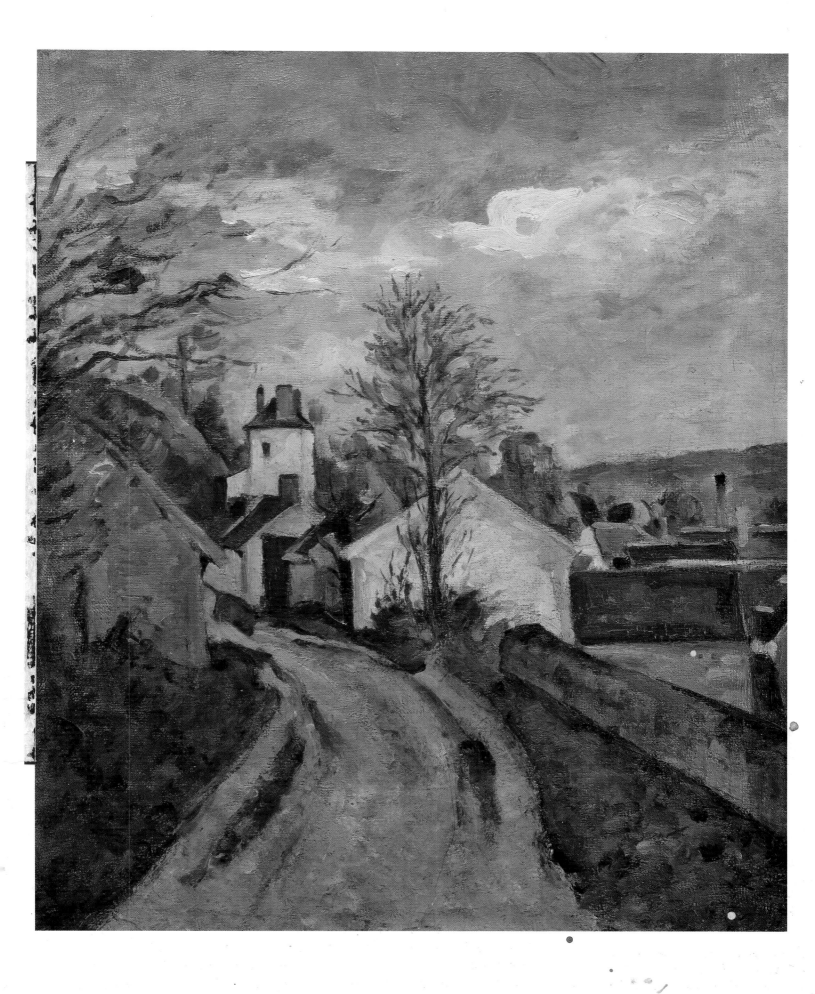

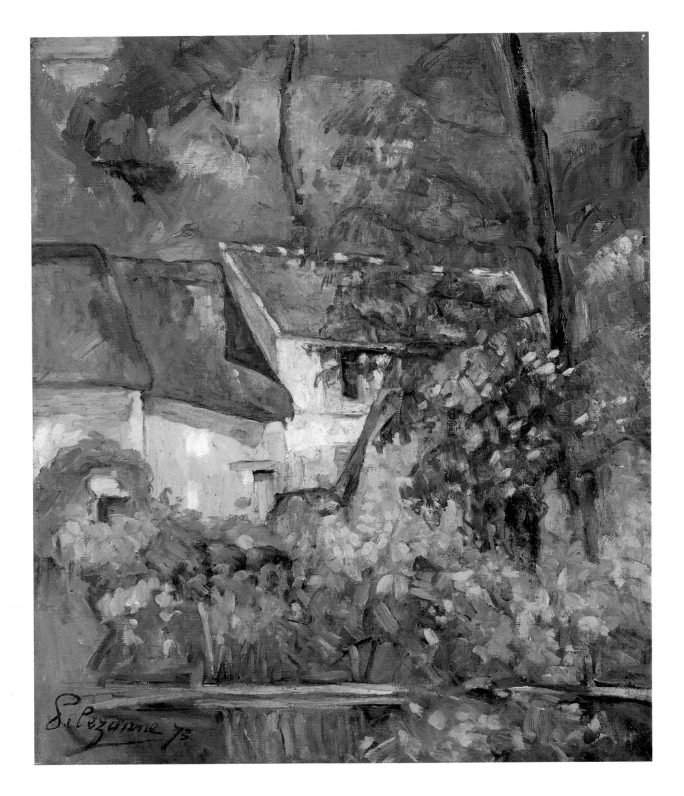

The House of Père Lacroix in Auvers, 1873
La maison du père Lacroix à Auvers
Oil on canvas, 61 x 51 cm
Venturi 138; Washington D.C., National Gallery of Art,
Chester Dale Collection

Although Cézanne's paintings from this period are brighter and more
vibrant than his early works, they are more strictly composed than
those of the Impressionists who, like him, came to Auvers to paint.

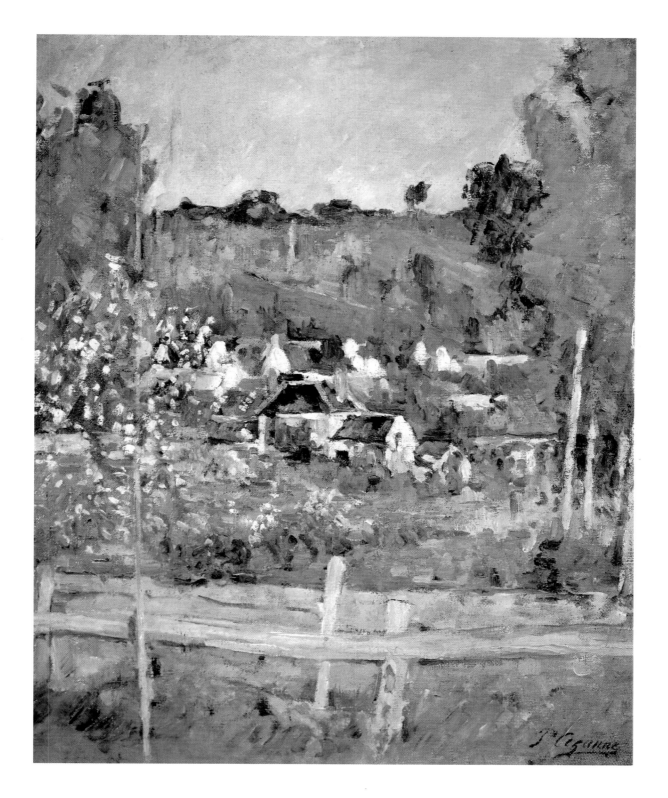

View of Auvers-sur-Oise – The Fence, 1873
Vue d'Auvers-sur-Oise (La Barrière)
Oil on canvas, 44.5 x 34.5 cm
Venturi 149; private collection

Cézanne's palette became much brighter as a result of working with
Pissarro. He increasingly avoided continuous areas of dark colour in
favour of a more relaxed, dotted style of painting.

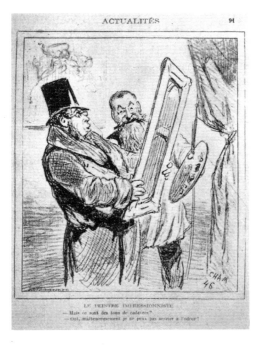

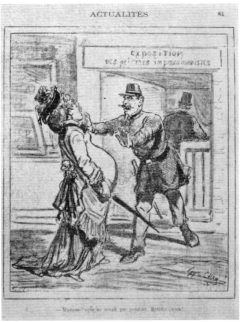

Caricatures from the satirical magazine *Charivari*, drawn by Cham, 1877
Drawings

The Impressionist Painter
"But those are the colours of a corpse!"
"Yes; unfortunately I can't get the smell right."

Exhibition by the Impressionist painters
"Madam, that would not be wise. Do not come in!"

became more even and angular, often painted in parallel diagonals. The spots of paint which he so energetically applied to the canvas had strong shapes which give his pictures a rigorous, serious effect. The impression of flamboyant haste was replaced by a feeling of stability and permanence.

Cézanne continued to work quietly at Pissarro's side. He made progress, and Pissarro thought very highly of him. "Our friend, Cézanne, raises our expectations," he reported, "and I have seen and have at home a painting of remarkable vigour and power. If, as I hope, he stays some time in Auvers, where he is going to live, he will astonish a lot of artists who were too hasty in condemning him."

Another admirer of his paintings, Dr Paul-Fernand Gachet, had come to live in Auvers-sur-Oise, a neighbouring village to Pontoise. Dr Gachet was a highly distinctive character with unorthodox views, who dyed his hair yellow and wore unconventional clothes. He admired Gustave Courbet and Victor Hugo and frequented the Paris cafés where avant-garde artists met. He also dabbled in painting in his spare time and was interested in everything which was new and revolutionary. He had met Cézanne through Pissarro, and he persuaded him to come and live nearby in Auvers.

There, amid the total tranquillity of the idyllic countryside, Cézanne discovered the many subtle nuances of nature. He constantly overpainted and corrected his paintings to preserve the rich sumptuousness of the reality he observed. He was never satisfied, and never really felt he had completed a painting. He would keep bringing out the canvas again and again and try to record what he had seen in even greater detail.

He felt happy in the company of Gachet and his wife; for the first time, someone was displaying a passionate interest in his work.

One day, the discussion turned to Manet's painting *Olympia* (1863, ill. p. 30), the work which had caused such a scandal at the Salon of 1863, and Cézanne's version, *A Modern Olympia*, painted three years previously (1869–1870, ill. p. 31). Cézanne promptly took up his brush and painted a second version, unusually quickly by his standards (1873, ill. p. 32). This relaxed painting, full of subtle irony, differs from the earlier version, which was stiffer and clumsier; it has a soft, delicate vividness which captures the sensuality of the scene. The unadorned, direct realism of the naked prostitute, who appears to the customer as though in a haze of opium, as the unattainable object of his desire, is completely different from the very cool, distancing view of nudity in Manet's *Olympia*. However, there are parallels with Cézanne's painting *Déjeuner sur l'herbe* (1869–1870, ill. p. 30). In both figures, the artist himself is shown with his back to us, in the same pose and wearing the same clothes, right down to the black top hat. Both times, temptation lies in front of him on a white cloth: in *Déjeuner sur l'herbe* it takes the form of apples, the "forbidden fruits"; in *A Modern Olympia* it is an unreal dreamlike image, transcending the banal reality of everyday life. Dr Gachet bought this second version of 1873. It was the first time Cézanne had sold one of his paintings.

Cézanne continued to express his visions of the female in paintings, in an attempt to come to terms with his obsessions and fears. But the older he grew, the more he avoided contact with women, and it was not long before his feelings for Hortense Fiquet were a thing of the past. Closest to him were his mother and his sister Marie, whom he greatly loved. Later, when he was living mainly in Aix, he stopped using female models altogether, partly out of consideration for the prudish, provincial attitudes of the local people, but partly also because throughout his life he never managed to rid himself of his shyness, fear and mistrust of women.

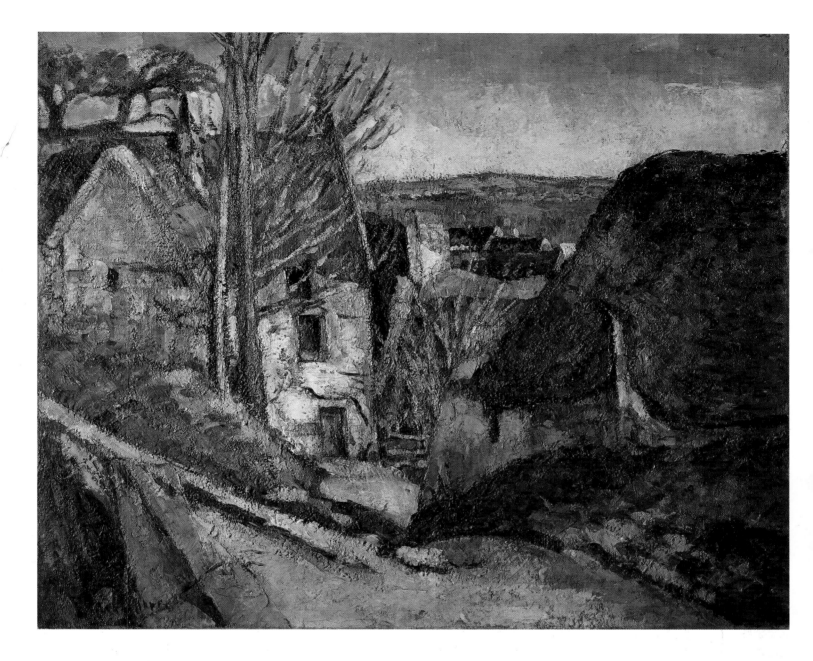

In 1873, again through Pissarro, Cézanne met the Parisian paint dealer Julien Tanguy, a Breton aged about fifty, who immediately struck up a strong rapport with him. "Père Tanguy" had strong opinions about art and supported Pissarro, Sisley, Van Gogh (whom Cézanne met at his house), Guillaumin, Gauguin, Signac and Seurat by accepting paintings in exchange for supplies of canvas and paint. Meeting Tanguy was a great stroke of luck for Cézanne: Tanguy acquired many of his paintings and at least freed him from the worry of obtaining materials. Nonetheless, Cézanne's financial situation was worse than it had ever been. He had a small bachelor's allowance to feed a family of three, and he was far from achieving public recognition or selling any paintings.

The other artists in the Batignolles group were faring no better. Their paintings were still being rejected by the jury at the Salon, whose criteria had not changed under the Third Republic. Only Manet's Old Master-like painting *Le bon bock* was accepted by the Salon in 1873.

The young painters realized that they had no chance of getting into the official Salon, and so they returned to Monet's plan, hatched in the Café Guerbois back in 1867, to organize and finance their own group exhibition.

The House of the Hanged Man at Auvers, 1872–1873
La maison du pendu à Auvers
Oil on canvas, 55.5 x 66.5 cm
Venturi 133; Paris, Musée d'Orsay

The first exhibition by the Impressionists (the name was coined by a critic based on Monet's painting *Impression – Sunrise*) on 15 April 1874 met with public ridicule and incomprehension. Visitors came in droves, but only to mock. This was one of the few paintings which was sold during the exhibition; it was bought by the Count of Doria for 300 francs.

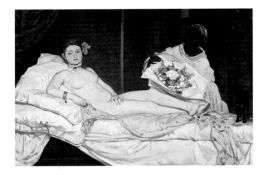

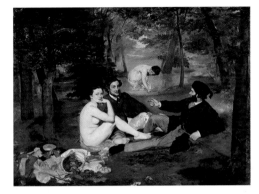

Edouard Manet:
Olympia, 1863
Oil on canvas, 130.5 x 190 cm
Paris, Musée d'Orsay

Edouard Manet:
Le déjeuner sur l'herbe, 1863
Oil on canvas, 208 x 264 cm
Paris, Musée d'Orsay

Déjeuner sur l'herbe, 1869–1870
Oil on canvas, 60 x 80 cm
Venturi 107; private collection

Manet's motif of the *Déjeuner sur l'herbe* is
taken up in a very distinctive and dramatic
composition by Cézanne. Unlike in Manet's
painting, it is difficult to identify the relation-
ships between the figures here, though the
figure in the foreground with his back to us is
probably the artist himself. The apples, as
symbolic objects, form the focal point of the
composition.

The exhibition by the *Société anonyme des artistes, peintres, sculpteurs,
graveurs etc.*, as the group was officially called, was held in the studio of
the photographer Gaspard Félix Nadar on the Boulevard des Capucines. It
opened on 15 April 1874 and lasted for a month. The exhibition included
works by Renoir, Monet, Sisley, Berthe Morisot, Degas and Pissarro, as
well as by some less controversial artist friends of Degas. Pissarro invited
Cézanne to exhibit, against the wishes of some of the members, who feared
that Cézanne's very daring paintings could damage the group. Manet prompt-
ly and angrily withdrew from the exhibition, describing Cézanne as "a
bricklayer who paints with his trowel". He hoped to achieve greater success
by taking part in the official Salon.

The exhibition unleashed a hail of ridicule and hilarity among the public
and the critics. They joked that the artists must have painted their pictures
by loading pistols with tubes of paint and firing them at their canvases.
Cézanne, as the painter of *A Modern Olympia*, was described by the critic
of *L'Artiste* as a madman painting in a state of *delirium tremens*. Emile
Zola, who as a friend could have taken up the cudgels on the group's behalf,
was not forthcoming. He was more interested in his gigantic series of
novels, the family epic *Les Rougon-Macquart*. He visited the exhibition,
but only to take notes for his novel about an artist, *L'Œuvre*, whose hero
was reputedly Cézanne.

The novel describes the Batignolles group exhibition as follows:

"These laughs were no longer smothered by the handkerchiefs of the
ladies, and the men distended their bellies the better to give vent to them.
It was the contagious mirth of a crowd that had come for entertainment,
was becoming excited by degrees, exploded apropos of nothing, and was
enlivened as much by beautiful things as by execrable ones... every canvas
had its appreciation, people called one another over to point out a good one,
witty remarks were constantly being passed from mouth to mouth... The
round and stupid mouth of the ignorant who criticize painting, expressing
the sum total of asininity, of absurd commentary, of bad and stupid ridi-
cule, that an original work can evoke from bourgeois imbecility."

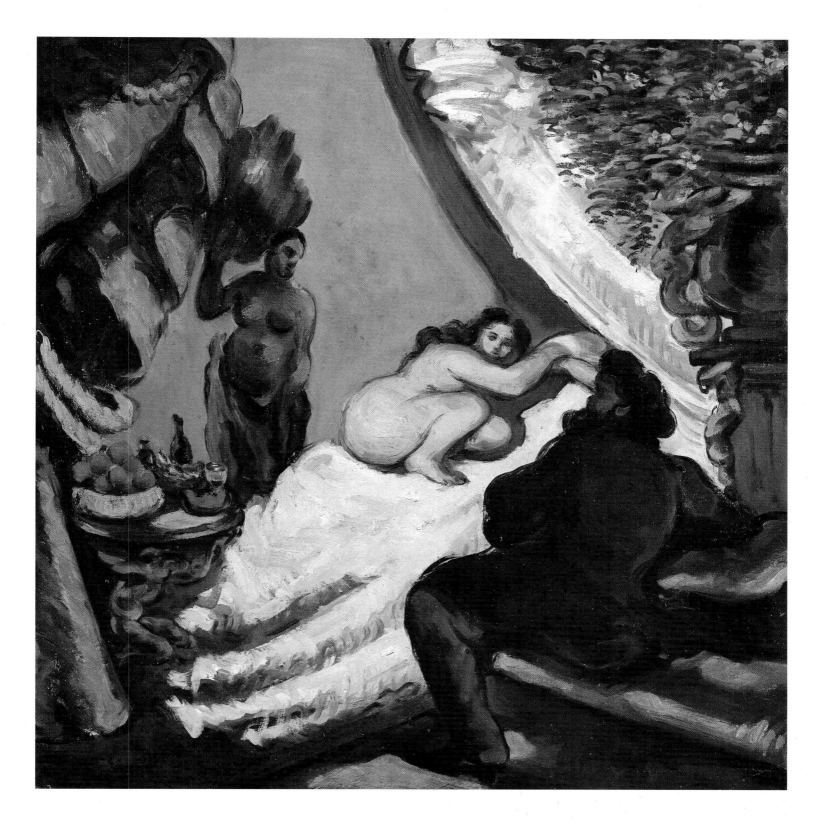

A Modern Olympia, 1869–1870
Une moderne Olympia
Oil on canvas, 57.5 x 57 cm
Venturi 106; private collection

Inspired by Manet's scandalous painting of 1863,
Cézanne painted a wildly expressive version
of the motif.

A Modern Olympia, 1873
Une moderne Olympia
Oil on canvas, 46 x 55 cm
Venturi 225; Paris, Musée d'Orsay

"On Sunday the public saw fit to sneer at a fantastic figure that is revealed under an
opium sky to a drug addict. This apparition of pink and nude flesh pushed, in the empyrean
cloud, by a kind of demon or incubus, like a voluptuous vision – this corner of artificial
paradise, has left even the most courageous gasping for breath. Mr Cézanne merely gives the
impression of being a sort of madman who paints in *delirium tremens*." This was a
female critic's opinion of Cézanne's painting at the first Impressionist exhibition in April 1874.

Afternoon in Naples (Rum Punch), 1872–1875
L'après-midi à Naples
Oil on canvas, 37 x 45 cm
Venturi 224; Canberra, National Gallery of Australia

This openly provocative and sensual painting shows a naked couple in bed, being
served with a love potion by an exotic serving-maid. The picture was regarded as an offence
against public decency, as well as against the Salon, and of course this unambiguous
painting was rejected.

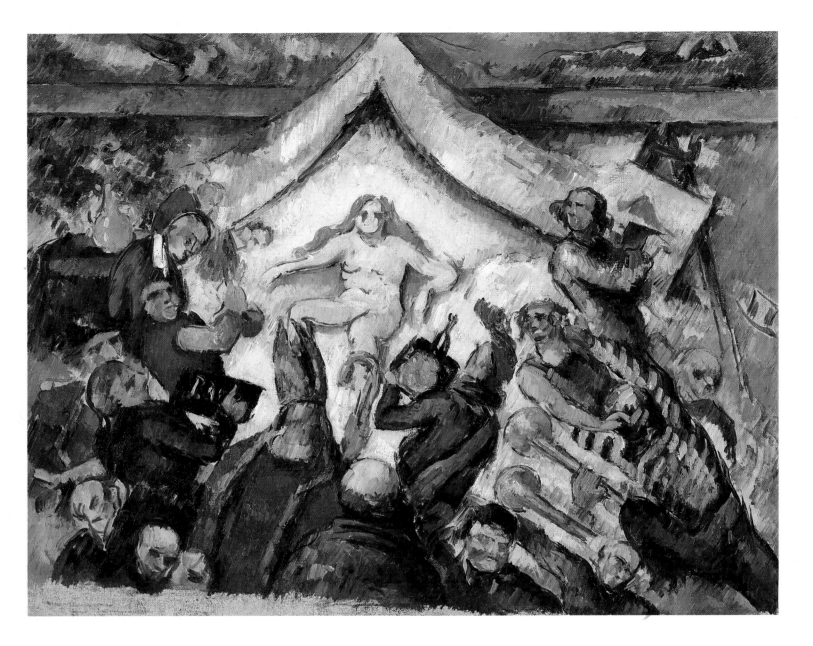

The Eternal Feminine, 1875–1877
L'eternel féminin
Oil on canvas, 43.2 x 53.3 cm
Venturi 247; Malibu (CA), The John Paul
Getty Museum

A broad cross-section of male society pays
homage to its naked idol, who is holding
court under a white canopy in a room which
looks out over the countryside. The female
figure has been stripped of her individuality,
and lies defenceless and exposed to the men's
gaze; she is subject and object, exploiter and
exploited all in one. This painting bears
witness to Cézanne's own mixture of fear and
longing for the female sex.

A critic from the satirical magazine *Charivari* scornfully dubbed the group
the "Impressionists", after Monet's painting, *Impression – Sunrise*. This
name quickly caught on, and replaced the original tag, "Intransigeants".

The mercilessly scathing verdict from the critics inevitably helped to
deter potential buyers. But some paintings were sold, including Cézanne's
work *The House of the Hanged Man at Auvers* (1872–1873, ill. p. 29),
which was bought by a collector, the Count of Doria, for 300 francs.

When the final accounts were drawn up for the exhibition, there was a
deficit of 184.50 francs for each participant. Cézanne probably had to ask
his father to settle his debts, and in May 1874 he went back to his parents'
house in Aix-en-Provence.

Although the enterprise had been a failure of the first order, Cézanne
remained self-confident, and seemed to be increasingly indifferent to public
opinion. Back in Paris, he wrote to his mother: "I begin to find myself su-
perior to those around me, and you know that the good opinion I have of
myself has only been reached after mature consideration. I must always
work, but not to achieve a final polish, which is for the admiration of im-
beciles. And this thing which is commonly so appreciated is only the ac-

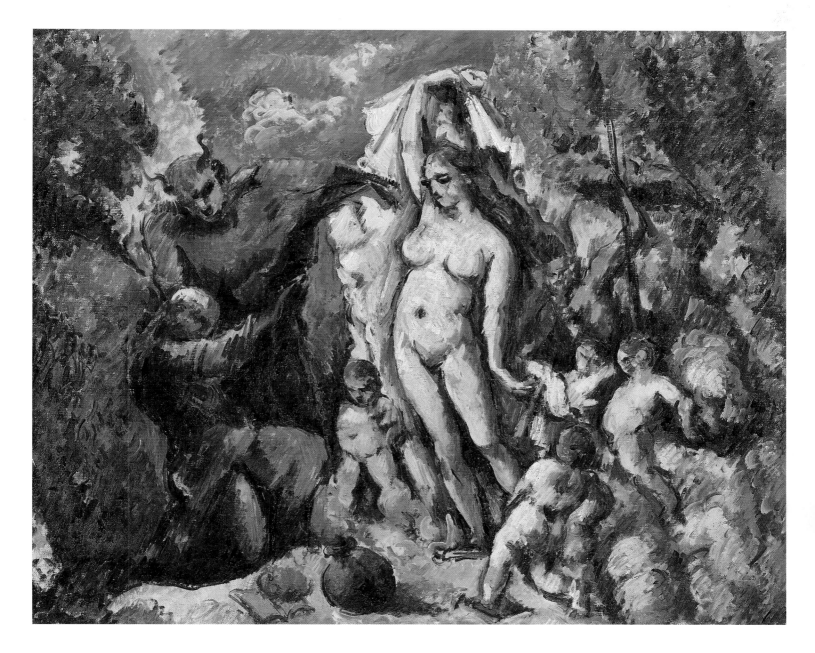

complishment of an artisan's skill and makes every work resulting from it in-artistic and vulgar. I must strive after completion only for the pleasure of giving added truth and learning. And believe me, there always comes a time when one arrives, and one has much more fervent and devoted admirers than those who are flattered by vain appearances."

Because of the artists' desperate financial straits, there was no question of organizing a group exhibition in 1875. Instead, they held an auction of their paintings in the Hôtel Drouot. This was a fiasco, and a financial disaster, but it did bring them into contact with an enthusiastic art-lover and collector, a customs inspector named Victor Chocquet. Through Renoir, Chocquet soon met Cézanne, and a warm and close friendship grew up between the two.

Chocquet was the quintessential private collector who follows only his own tastes and ignores passing fashions and public opinion. His friendship with Cézanne was strengthened by the fact that both of them revered Delacroix.

Chocquet had accumulated a significant collection of paintings and antiques in his apartment in the Rue de Rivoli, including twenty works by

The Temptation of St Anthony, 1873–1877
La tentation de Saint-Antoine
Oil on canvas, 47 x 56 cm
Venturi 241; Paris, Musée d'Orsay

The legend of St Anthony, the Egyptian hermit, was a particularly popular subject with artists in the second half of the 19th century. Cézanne has transposed the "temptation" to a romantic level and particularly emphasizes the sexual aspect of the story.

Delacroix alone, and works by Courbet, Manet and Corot. When the Impressionists held their second exhibition in 1876, he loaned paintings by Renoir, Pissarro and Monet.

Cézanne did not take part in this second exhibition, possibly because he could not afford to pay his share of the cost. He submitted one painting to the Salon which, as always, was rejected. At the beginning of April, when the exhibition opened, he was already back in Provence.

Increasingly he became aware that the Provençal landscape came closest to his artistic objectives. Its bright light and strong contrasts, its parched, barren appearance and sharply defined forms were in complete contrast to the gentle, undulating landscapes of the Ile-de-France painted by his Impressionist friends. The Aix region was also rich in natural formations, with its jagged cliffs and cracked earth providing powerful contrasts.

The light there was not the soft, dispersed light which gives the countryside a gentle, cheerful appearance. The sun was merciless, the light glittering and harsh, and any clouds were whisked away by the Mistral to leave a steely blue sky.

In this landscape Cézanne found the basic, unchanging structures of nature, which vary little from one hour to the next or from season to season.

Pool at the Jas de Bouffan, 1882–1885
Bassin du Jas de Bouffan
Oil on canvas, 73 x 60 cm
Venturi 417; Buffalo (NY), Albright-Knox
Art Gallery, Fellows for Life Fund

The grounds of the Jas de Bouffan, with their avenue of chestnut trees and stone pool, were the subject of many of Cézanne's paintings. The bright colours and parallel layers of brushstrokes reflect the influence of Pissarro.

The wiry vegetation, and the evergreen foliage of the olive trees, pines, cypresses and oaks, suited his slow pace of working; even if he spent months working on a landscape, it changed very little. This meant that he could reconstruct nature on the canvas, as he perceived it, in complete tranquillity and with rigorous discipline.

In the summer, he went to L'Estaque, which was then an idyllic fishing village on a bay in the Mediterranean, to paint landscapes for Victor Chocquet. Around six years had elapsed between *Snow Thaw in L'Estaque* (c. 1870, ill. p. 23) and *The Sea at L'Estaque* (1876, ill. p. 39) – and what a change! Cézanne had clearly learned a great deal from Pissarro during this period, and added a great deal of his own. This brightly coloured seascape is serene and formal. The painting is carefully structured, with the strong colours – the terracotta roof tiles, the green foliage, the blue surface of the water – covering the surface of the canvas with an even intensity. There is no definable lighting; only the red chimney is glowing in the low sun.

It is not the light which breaks up the outlines of the forms and renders them hazy and indeterminate, and this has a very disorienting effect. Instead of light, the forms are defined by strength and modulation of colour. It is colour which determines the nature of objects and both brings them nearer to the viewer and places them an immeasurable distance away. We can see from this painting that Cézanne has become a close observer of nature, and nothing has been added purely for effect. Of course the artist's

Trees in the Jas de Bouffan, 1875–1876
Arbres au Jas de Bouffan
Oil on canvas, 54 x 73 cm
Venturi 161; private collection

The motif in itself is unspectacular, but Cézanne has made intensive but carefully controlled use of colour to create a sundrenched park landscape.

particular viewpoint has been carefully chosen, and the diagonals of the hill and the overlapping tree trunks have been deliberately included to create tension. But this picture is one of mature tranquillity, showing the artist's profound respect for the splendour of the landscape.

On 2 July 1876, Cézanne wrote to Pissarro about L'Estaque:

"I have not been in Aix for the past month. I have begun two small pictures of the sea for Mr Chocquet, who had spoken to me about them. It is like a playing-card. Red roofs on the blue sea. If the weather gets better, I could possibly finish them both. As things are at the moment, I have not done anything yet. But there are compositions which would take three to four months' work, which could probably be done, because the vegetation does not change. There are olive trees and stone pines, which always keep their leaves. The sun is so terrifying that it seems as though the objects are silhouetted, not only in black or white, but also in blue, red, brown, and violet. I may be mistaken, but it seems to me to be the very opposite of modelling. How happy our gentle landscape painters from Auvers would be here... If I can, I will spend at least a month in this place, for one would need to paint pictures at least two metres in size."

Roofs, c. 1877
Les toits
Oil on canvas, 47 x 59 cm
Venturi 1515; private collection

This is one of Cézanne's few townscapes, painted in bright, Impressionist colours and flowing brushstrokes by the "Little Master of Impressionism", as he once described himself.

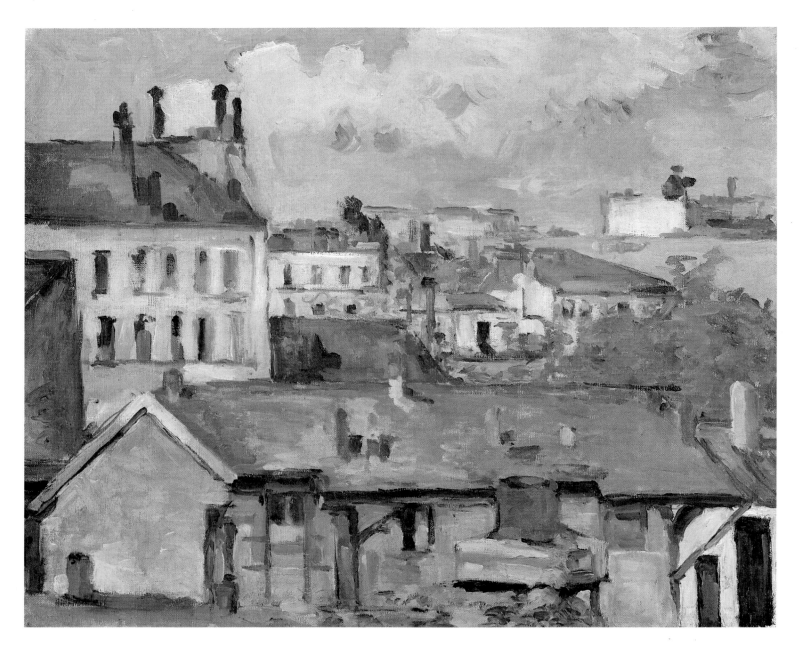

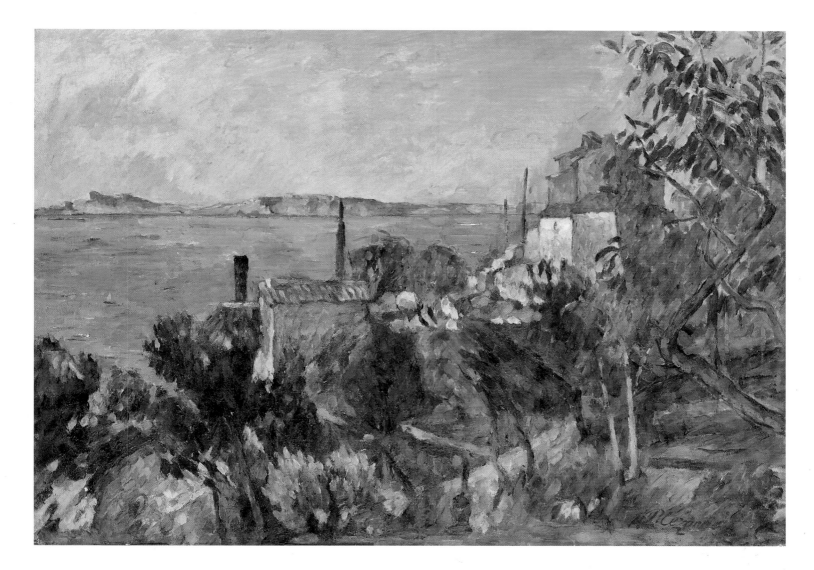

The Sea at L'Estaque, 1876
La mer à l'Estaque
Oil on canvas, 42 x 59 cm
Venturi 168; Zurich, Fondation Rau
pour le Tiers-monde

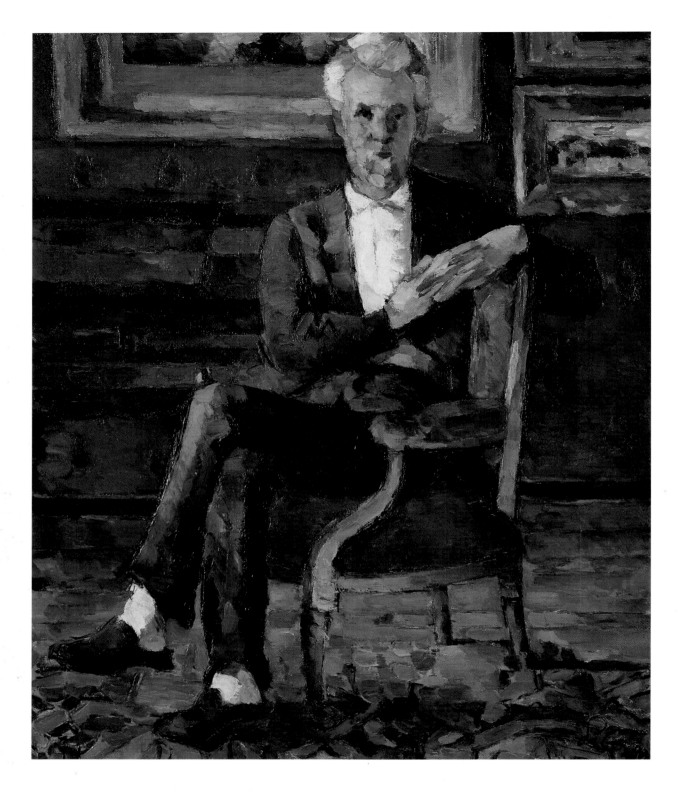

Portrait of Victor Chocquet, 1879–1882
Portrait de Victor Chocquet
Oil on canvas, 46 x 38 cm
Venturi 373; Columbus (OH), Columbus Museum of Art, Howald Fund

ILLUSTRATION PAGE 41:
Madame Cézanne in a Red Armchair
(Madame Cézanne in a Striped Skirt), c. 1877
Madame Cézanne dans un fauteuil rouge
Oil on canvas, 72.5 x 56 cm
Venturi 292; Boston (MA), Museum of Fine Arts, Bequest of Mrs H.O.
Havemeyer, Robert Treat Paine II Foundation

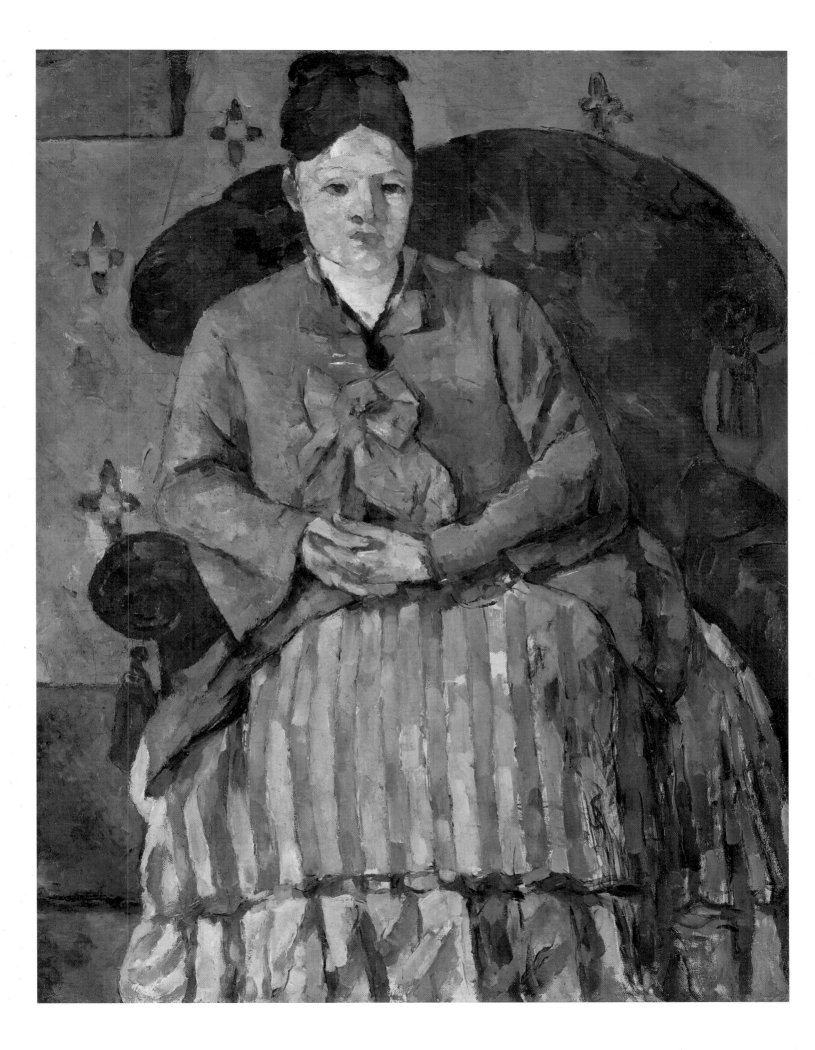

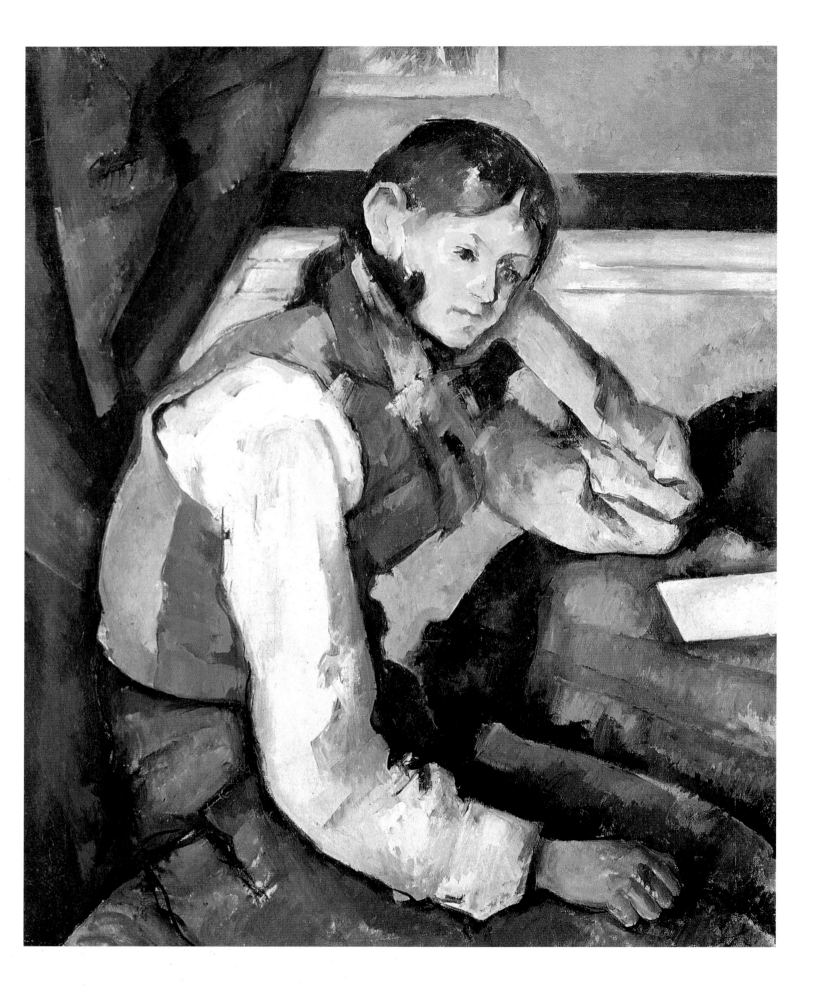

"Harmony in parallel with nature"

"The artist who has been the most attacked, the most mistreated by the press and the public for the past fifteen years is Mr Cézanne. There is no outrageous epithet that has not been attached to his name; his books have had a success in ridicule and continue to have it... For my part, I do not know of any painting less laughable than this."

Georges Rivière, an art critic and friend of Renoir, wrote a defence of Cézanne during the Impressionists' third group exhibition, in May 1877. He continued:

"Mr Cézanne is, in his works, a Greek of the great period; his canvases have the calm and heroic serenity of the paintings and terracottas of antiquity... His beautiful still-lifes, so exact in the relationship of tones, have a solemn quality of truth. In all his paintings, the artist produces emotion because he himself experiences violent emotion in the face of nature that all his craftsmanship transmits to the canvas."

But Rivière's was a lone voice; few showed such sympathy and understanding for Cézanne's new and subjective approach to painting after seeing the exhibition. The comments in the Paris newspapers, which gave detailed coverage to events in the art world, were largely mocking and cynical. Cézanne decided to stop exhibiting with the Impressionists (although they asked him not to leave), and to concentrate more on getting into the Salon.

Towards the end of the year he returned to southern France to paint in L'Estaque. The paintings from this period include two landscapes showing Cézanne's view of nature in two very different ways. In *Rocks at L'Estaque* (1882–1885, ill. p. 44), Cézanne is particularly interested in the rocky pinnacles, scarred by erosion and covered in sparse, wiry vegetation, but he gives us nothing by which we can gauge the actual size of this natural formation. Are the rocks so huge that a person standing in the foreground would have been dwarfed by them, or are we looking at them close-up, so that they are in fact fairly small? There is no way of knowing, and the roof near the sea, the only sign of civilization in this vast natural landscape, does not help to establish a sense of scale. The proportions remain unclear.

Cézanne has used a very limited palette in this painting: bluish-grey for the rocks, green for the vegetation, and ochre for the soil; but there are complex tonalities within this small range of colours. The rocks on the left of the picture are lit by the late evening sun and are painted in light ochre, while the overhangs of the rocks are in shadow and are painted a dark, saturated blackish-green. Very subtle nuances of colour in the foreground are used to create the dramatic effect of the setting sun, while the background of sea and hills is uniform and monochrome in structure. But the dramatic appearance of the rock formations is not primarily the result of a momentary effect of light, or where the sun happens to be at that particular

Studies, c. 1876–1884
Pencil and black chalk, 49.5 x 32 cm
Rotterdam, Museum Boymans-van Beuningen

This page contains sketches spanning several years: a "Lament of Psyche" from the Louvre, a self-portrait, aged about forty-five, and a portrait of the artist's young son asleep.

ILLUSTRATION PAGE 42:
Boy in a Red Waistcoat, 1890–1895
Le garçon au gilet rouge
Oil on canvas, 79.5 x 64 cm
Venturi 681; Zurich, Stiftung Sammlung E.G. Bührle

This painting, whose tension derives wholly from the distribution of areas of colour, was described by Gustave Geffroy as a work which "bears comparison with the finest figure pictures in painting".

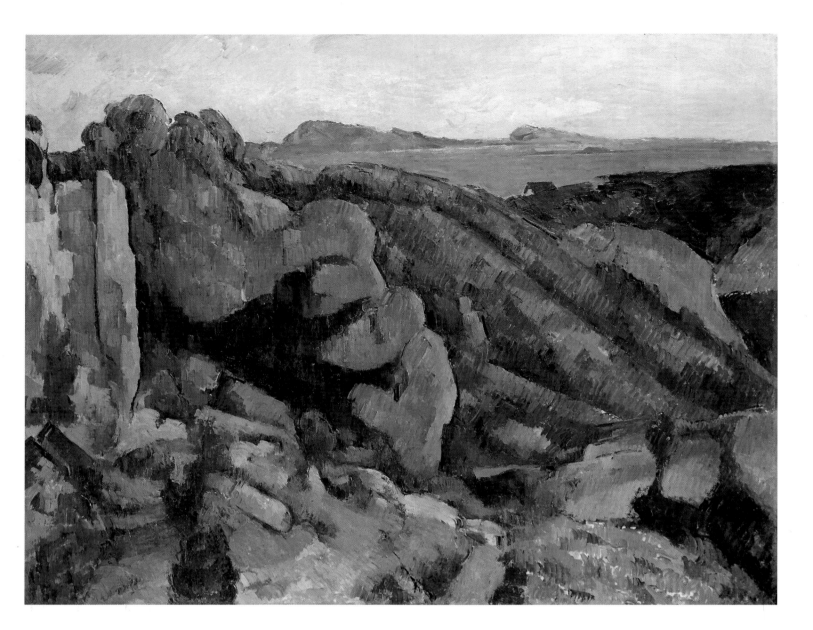

Rocks at L'Estaque, 1882–1885
Rochers à l'Estaque
Oil on canvas, 73 x 91 cm
Venturi 404; São Paulo, Museo de Arte de
São Paulo Assis Chateaubriand

Emile Zola said of the landscape at
L'Estaque:
"Nothing equals the wild majesty of these
gorges hollowed out between the hills,
narrow paths twisting at the bottom of an
abyss, arid slopes covered with pines and
with walls the colour of rust and blood.
Sometimes the defiles widen, a thin field of
olive trees occupies the hollow of a valley, a
hidden house shows its painted façade with
closed shutters. Then again, paths full of
brambles, impenetrable thickets, piles of
stones, dried-up streams; all the surprises of a
walk in the desert."

moment. Rather, the light seems to come from the objects themselves. The
effects of colour and form reinforce each other, breaking down the land-
scape into a huge agglomeration of spots of colour.

Here again, Cézanne has used the technique of short brushstrokes which
he learned from Pissarro. But he has used it with great freedom; where he
wants to create compact forms whose structure is defined by light, he uses
larger, more solid brushstrokes, whereas the areas of vegetation, which
have a greater variety of colour, are created using smaller, more broken
strokes.

Cézanne used a more traditional composition in his painting *The Sea at
L'Estaque* (1883–1886, ill. p. 45), which was acquired by Pablo Picasso in
the 1940s. The eye is led from the road running across the picture in the
foreground to the village on the hillside and finally to the sea, which stret-
ches to the horizon in the far distance. This horizontal structure is broken
by the vertical chimney and the two trees in the foreground, which, very
much in the Baroque tradition of the *repoussoir* or strong foreground, in-
crease the feeling of depth in the painting. Here we can clearly see the ar-
tistic problems of linking the planes together, the treatment of the large area
of sea, and the conflict between line and plane.

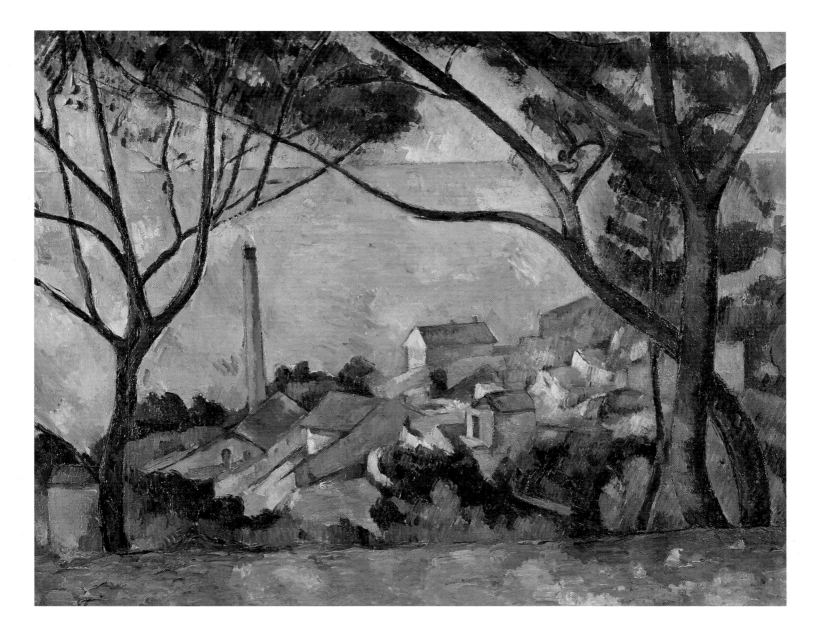

Life in L'Estaque caused Cézanne considerable difficulties. He had installed Hortense and their son Paul in a small apartment and travelled back and forth between L'Estaque and Aix, constantly fearing that his father might discover the existence of his family.

Louis-Auguste Cézanne had retired from his banking business after the Franco-Prussian War. He transferred his assets to his two daughters and his son Paul to reduce their liability to inheritance tax.

This did not mean that they could actually make use of the money; it was administered by their father, who was more distrustful of Paul than ever before: his son had disappointed him in every respect. He found out about Cézanne's liaison when Victor Chocquet inadvertently let slip a comment about "Madame Cézanne and little Paul", and promptly reduced his monthly allowance by half. Cézanne was forced to ask his friend Zola for help.

Although Cézanne still occasionally went out painting from nature with Pissarro, he was becoming increasingly distant from the Impressionists. He felt that Impressionist paintings were too transient, too much rooted in the moment. Cézanne was not satisfied simply with putting down what he saw onto canvas; he wanted to penetrate deep into the heart of nature and

The Sea at L'Estaque, 1883–1886
La mer à l'Estaque
Oil on canvas, 73 x 92 cm
Venturi 425; Paris, Musée Picasso, Donation Picasso

Cézanne has clearly separated the planes of the picture and used the Baroque tradition of the *repoussoir* to increase the impression of depth.

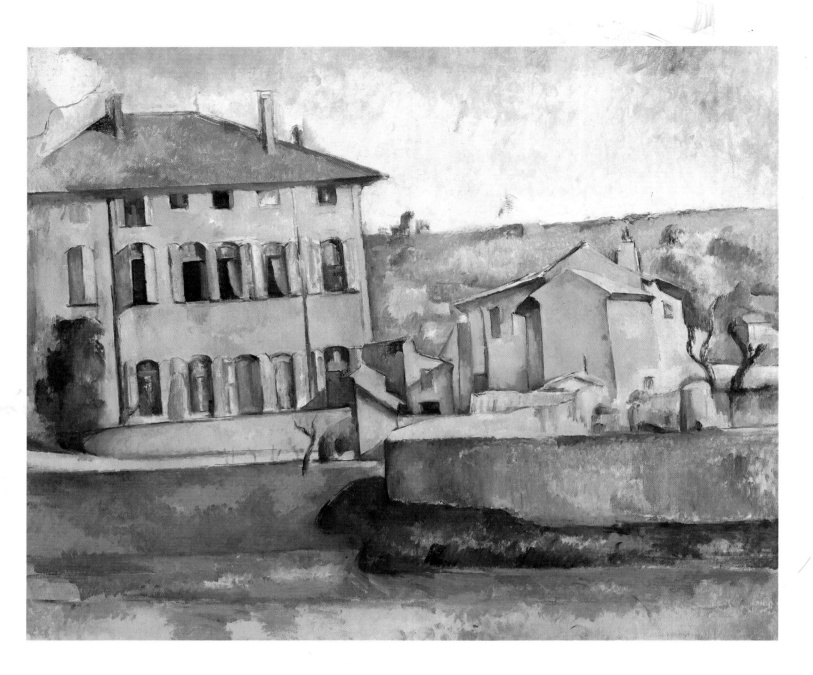

House and Farm at Jas de Bouffan,
1885–1887
Maison et ferme du Jas de Bouffan
Oil on canvas, 60 x 73 cm
Venturi 460; Prague, National Gallery

The Jas de Bouffan estate provided an unfailing source of peace and tranquillity for Cézanne. In this picture, the house seems to be drawing the sun into itself, almost turning to face it.

depict what was immutable and permanent in it. "You must think," he wrote; "the eye is not enough, it needs to think as well."

Cézanne would work on the same painting for long periods, sometimes months at a time. Transient, momentary effects of light and reflections were of secondary importance; indeed, they were almost a hindrance. "Nature causes me the greatest of difficulties," he wrote to Zola in 1879. He would sit with stubborn determination in front of his subject, contemplating nature and trying to understand the essence of things: their inherent, eternal form. His goal as an artist was to give things permanence. This meant that every subject had to be placed in a compositional balance which was the result of calculation, reflection and logic.

The same carefully structured compositions are apparent in his portraits. His *Madame Cézanne in Blue* (c. 1885–1887, ill. p. 53) shows Hortense sitting against a background which is divided into two parts: on the right is a door, with strictly geometrical panelling; on the left is patterned wallpaper and the ornamental top of an occasional table. The pale, cool blue of the door is in sharp contrast with the warm earthy tones of the wall-hanging and the piece of furniture. Hortense is posed leaning slightly to one side, a

motionless, monumental figure. The flesh tints of her serious, withdrawn-looking face echo the colours of the background, and the opening of her jacket also helps to divide the composition into two.

The formal severity of the composition, which is built up using colours, and its concentration on the essentials, create an unbridgeable distance between ourselves and the subject of the portrait. The expressionless, inward-looking gaze creates a sense of timelessness, but without depriving the subject of her individuality. Cézanne uses a similar process in his portraits to that of his landscapes: they are formal, strict, with a monumental, permanent quality.

Cézanne was still dissatisfied with the results of his work, and even showed some sympathy with the jury of the Salon when they turned down yet another of his paintings. "I understand very well that it could not be accepted, because of my point of departure, which was too far away from the objective to be achieved, namely the reproduction of nature."

This reproduction of nature took place in two stages in Cézanne's work. Before he actually began painting, he would spend a long time looking at the subject. Cézanne had to "read" the subject first, and understand its essence, before he could start painting. Then, in the second stage, he would "realize" the structure of the painting based on the forms, colours and structures which he had created in this preliminary image. In this process, it was important that such forms were taken from the natural world and not from the painter's own imagination. The forms must retain a similarity with nature; they must remain "true" to it.

Cézanne's need to be true to nature did not simply mean reproducing exactly what he saw; nor did it mean superficial imitation. "We should not be satisfied with strict reality," Emile Bernard quotes him as saying, "the re-forming process which a painter carries out as a result of his own personal way of seeing things gives a new interest to the depiction of nature. As a painter, he is revealing something which no-one has ever seen before

Chestnut trees at the Jas de Bouffan in winter, c. 1935
Photograph

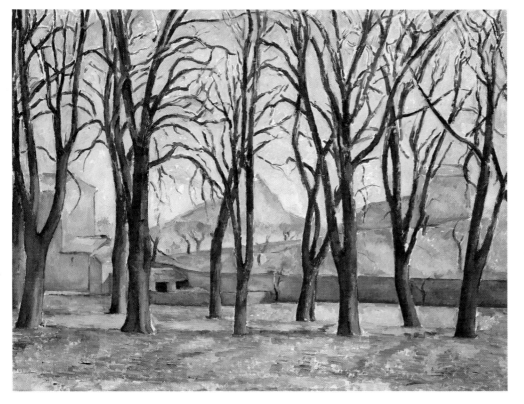

Chestnut Trees at the Jas de Bouffan in Winter, 1885–1887
Marronniers du Jas de Bouffan
Oil on canvas, 73 x 92 cm
Venturi 476; Minneapolis (MN), The Minneapolis Institute of Arts

Cézanne may faithfully depict what he sees, but he orders nature to fit his own compositional rules; the chestnut trees are arranged more neatly in the painting than they are in real life.

and translating it into the absolute concepts of painting. That is, into something other than reality."

These "absolute concepts of painting" are colours and forms, and the spatial relationships between them. Cézanne believed that being true to nature meant being true to these relationships. In this way, he sought to create a new harmony, which he called "harmony in parallel with nature".

Around the middle of the 1880s, Cézanne painted *House and Farm at Jas de Bouffan* (1885–1887, ill. p. 46), an unusual picture of his father's house in Aix. This house represented a haven of tranquillity amid all the difficulties of Cézanne's life. What is unusual about this particular painting, of a subject which he depicted many times, is the fact that the house has a distinct tilt to the left. The greyish-green hill on the right is also tilted in this same diagonal axis, as are the sunlit sides of the smaller outbuildings on the right. These are similar in colour to the yellow-orange tones of the main house, but slightly lighter, creating a diagonal tension which is accentuated by the bright red angular roof.

The deep green of the embankment also provides a counterpoint to the red roof of the house. There is therefore a contrast of colour between the complementary reds and greens, and a contrast of form between the linearity of the roof and the organic, rounded form of the embankment.

The bright green of the strip of grass at the bottom left is also just visible in the greenish-blue of the sky at the top left. This painting therefore contains two overlapping contrasts; these are not static, but are given movement by the fact that the house is inclined slightly backwards.

What were the feelings of the painter, what were his personal perceptions of the Jas de Bouffan, the "House of the Wind", when he painted this oddly angled picture of it? Like a person deliberately facing the sun to soak up as many of its warming rays as possible, the Jas de Bouffan is tilted slightly backwards so that its full richness of colour is revealed. The brightest area of blue in the picture is not the sky, but the open shutters, drawing the warmth of a Provençal summer's day into the house and turning it into a three-dimensional space. It comes as something of a surprise that although the planes of the painting are fairly compressed, and the house has a flat façade, it is actually a solid body. This impression could have been created using a strong source of sunlight from a particular angle, but it is not. The whole of the picture seems suffused with sunshine. The light comes from the colours themselves.

"We must not paint what we think we see, but what we see," Cézanne told the young poet Jean Royère in the mid-1890s. "Sometimes it may go against the grain, but this is what our craft demands... People will teach you the laws of perspective at the Beaux-Arts, but they have never seen that depth results from a juxtaposition of vertical and horizontal surfaces, and that is what perspective is. I have discovered it after long efforts, and I have painted in surfaces, because I do nothing which I have not seen, and what I paint exists."

So Cézanne's concern was far from being that of conveying the illusion of a three-dimensional world to the viewer. Rather he was creating a new reality using the two-dimensional surface of the painting. He simply sought to create an awareness of the two-dimensionality of the picture, this new "realization" of nature, and so it was important for him to avoid using traditional linear perspective, which creates the illusion of three-dimensional depth. In addition, if he had used strict linear perspective, he would have had to depict every object the size required by perspective. But what Cézanne wanted to do was to show each object the size which he saw it.

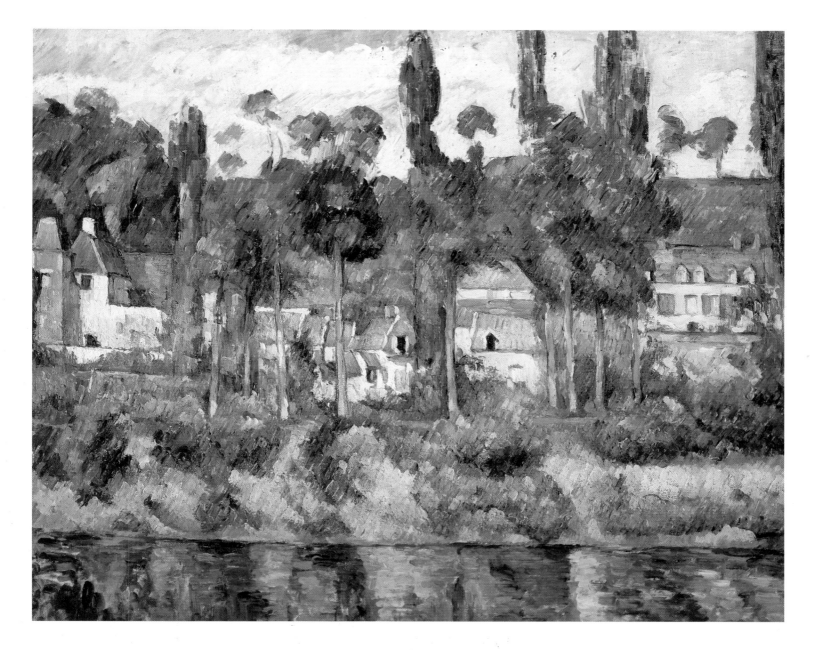

Apart from rejecting linear perspective, Cézanne also steered clear of the superior perspective so beloved of the Impressionists, in which the colours and forms of objects become more vague and indistinct the farther they are from the viewer.

Cézanne believed that colours and forms should be given equal weight and clarity wherever they appeared in the picture. The surface of the painting should be uniform in structure, and should eschew any form of illusion or naturalism. This meant that the incidence of light had to be almost the same throughout the picture, and he therefore largely avoided any references to a recognizable light source and the use of heavy shadows. The light is even, and comes from within the painting itself; the objects radiate their own light.

So if Cézanne avoided using traditional methods of creating space, how did he manage to ensure that his paintings nevertheless suggest space, without destroying the unity of the surface? He made use of the knowledge that cold colours, such as blue and green, appear to recede, and warm colours – red, orange, yellow – seem to stand out from the surface. He used this effect in his painting *Mardi Gras* (1888, ill. p. 51), which was posed for by his

The Château de Médan, 1879–1881
Le château de Médan
Oil on canvas, 59 x 72 cm
Venturi 325; Glasgow, Glasgow Art Gallery
and Museum

Cézanne used his visits to Zola's summer house in Médan to paint in the open air in the surrounding area, including Auvers, Pontoise and Bennecourt.

Study for *Mardi Gras*, 1886–1887
Etude pour le *Mardi Gras*
Pencil, 24.5 x 30.6 cm
Venturi 1622; private collection

son Paul, and Paul's friend Louis Guillaume. Another method which Cézanne used to create depth was the use of overlapping forms. This combination of flatness and depth is particularly conspicuous in his paintings of Mont Sainte-Victoire.

"I try to render perspective through colour alone," explained Cézanne. "I proceed very slowly, for nature reveals herself to me in very complex form, and constant progress must be made. One must see one's model correctly and experience it in the right way, and furthermore, express oneself with distinction and strength."

In April 1886, Cézanne married Hortense Fiquet in Aix, in the presence of his parents. The reason why, after so long, he decided to make his relationship with Hortense official, despite not having loved her for a long time, was probably to ensure that Paul did not suffer the stigma of having unmarried parents. He loved his son, now aged fourteen, to the point of idolization. Six months later, Cézanne's father died, aged eighty-eight, and Cézanne at last was able to claim his inheritance. For the first time in his life, the 47-year-old painter was financially independent.

"My father was a man of genius," he said, looking back. "He left me an income of 25,000 francs."

ILLUSTRATION PAGE 51:
Mardi Gras, 1888
Oil on canvas, 100 x 81 cm
Venturi 552; Moscow, Pushkin Museum

Cézanne's son Paul, and Paul's friend Louis Guillaume, posed for these figures from the Italian Commedia dell'arte, an unusual motif for the artist. Louis reportedly fainted during one sitting because Cézanne insisted that he should not move.

ILLUSTRATION PAGE 52:
Self-Portrait with a Palette, 1885–1887
Cézanne à la palette
Oil on canvas, 92 x 73 cm
Venturi 516; Zurich, Stiftung Sammlung E.G. Bührle

ILLUSTRATION PAGE 53:
Madame Cézanne in Blue, 1885–1887
Portrait de Madame Cézanne
Oil on canvas, 73 x 60 cm
Venturi 529; Houston (TX), The Museum of Fine Arts, The Robert Lee Blaffer Memorial Collection

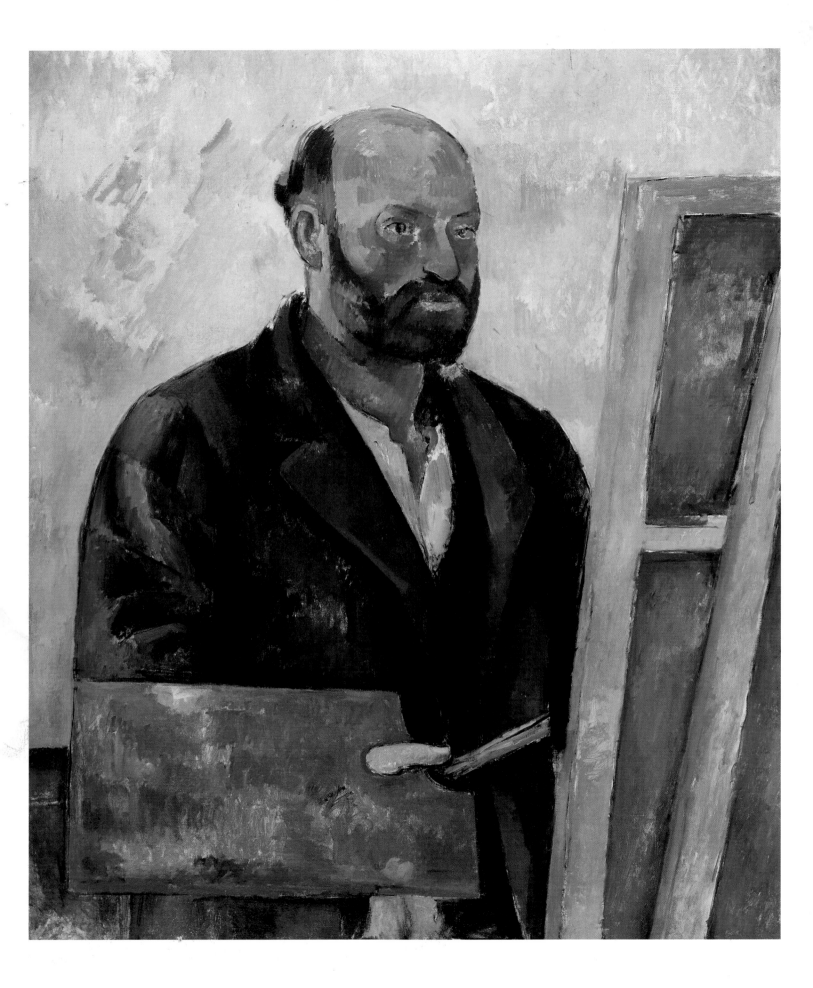

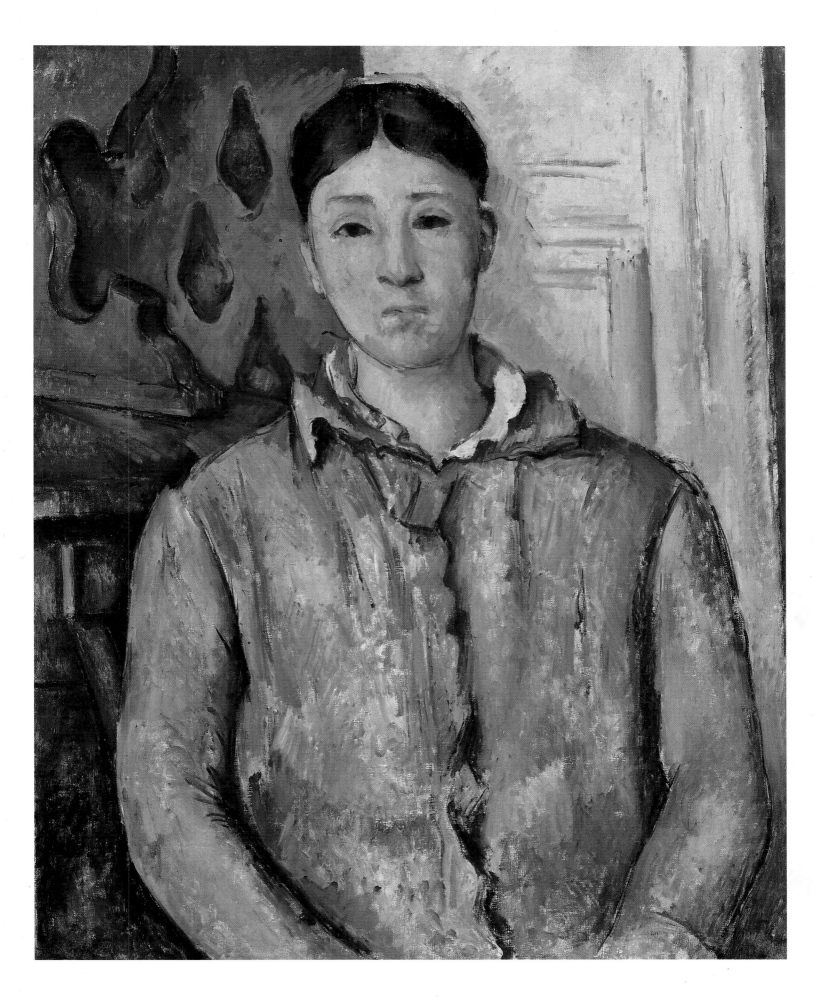

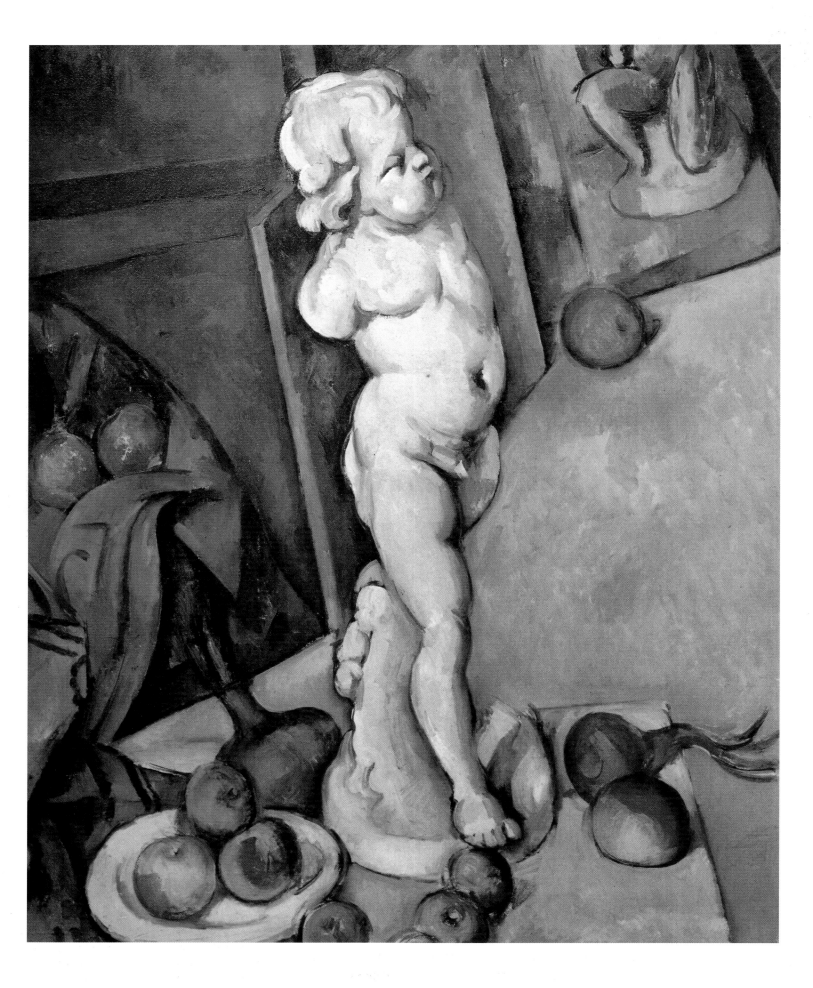

"I should like to astonish Paris with an apple" – The Still Lifes

Cézanne developed a completely new way of depicting objects in space. He reinvented still lifes on the basis of their two-dimensionality, and used purely artistic means to give them depth.

In *Cherries and Peaches* (1883–1887, ill. p. 56), the plate of cherries is tilted conspicuously forwards, as though we were looking down on it from above. The same is true of the back part of the table, but the front of it is painted as though we are seeing it horizontally. The plate of peaches and the jug are also painted from a lower angle.

There is a similar dual viewpoint in *Vessels, Basket and Fruit (The Kitchen Table)* (1888–1890, ill. p. 57), but here the same object is shown from two different viewpoints; the top of the basket of fruit is shown from above, and the side is viewed from the front. Much the same happens with the ginger jar in his *Still Life* (1890–1894, ill. p. 61). This is tilted forwards so that we can see in through the top, but the sides of the jar are depicted frontally. This distorted use of perspective suggests depth and at the same time emphasizes the two-dimensional nature of the picture's surface.

As Cézanne avoided using linear perspective in his depictions of objects, he could paint them so that their size was in proportion to their importance in the composition as a whole. In *Vessels, Baskets and Fruit,* for example, the pear on the right-hand edge of the table is disproportionately large. However, its size is important to the balance within the painting; it provides an offsetting counterpart to the variety of forms in the left-hand corner of the painting. Likewise, the red pear in the fold of the tablecloth, in the left foreground, counterbalances the similarly positioned red pear in the fruit basket. Although the forms in the painting appear at first sight to have been arranged at random, they in fact form a carefully thought-out composition which is full of tensions.

Cézanne set up all his still lifes in the studio. Some of the objects he used are still in his last studio on the Chemin des Lauves in Aix (photograph p. 55). Apart from the fruit, many of the objects, such as jugs, pots and plates, frequently recur in his compositions. The pictures often include a dramatically billowing white tablecloth, giving the paintings a touch of Baroque extravagance.

The forms of the containers are simple and plain, and the fruits mainly consist of very basic, round forms: onions, pears, peaches, and large numbers of apples. He found these fruits the easiest when it came to establishing volume; he did this using very subtle gradations of colour rather than resorting to techniques such as outlining or shadows.

Although Cézanne arranged his still lifes very carefully, he took great pains to avoid any impression of artificiality or sophisticated materiality; he was not trying to create a perfect illusion. As a result, some of his still

Table in Cézanne's last studio. The objects were used as motifs in his still lifes.

ILLUSTRATION PAGE 54:
Plaster Cupid and the "Anatomy", c. 1895
Nature morte avec l'amour en plâtre
Oil on paper and wood, 71 x 57 cm
Venturi 706; London, Courtauld Institute Galleries

The still life featuring the Baroque cherub, the plaster cast of which is still in Cézanne's studio today, comes to life through its contrasts of rounded forms (the cherub, the apple and the onions) and straight lines (such as the canvases and the edge of the table). It also makes use of the contrast between pale and strong colours.

Cherries and Peaches, 1883–1887
Cerises et pêches
Oil on canvas, 50 x 61 cm
Venturi 498; Los Angeles (CA), County
Museum of Art

The perspective of this picture is broken in
a number of ways; the plate of cherries is
shown from a different angle to the other
objects. The picture emphasizes the fact that
it is two-dimensional by refusing to use any
form of illusion.

lifes even show the normally unseen items, such as wooden blocks or books,
which he used to prop up objects in a tilted position. The young artist Louis
Le Bail wrote of these still-life arrangements by Cézanne:

"The cloth was very slightly draped upon the table, with innate taste.
Then Cézanne arranged the fruits, contrasting the tones one against the
other, making the complementaries vibrate, the greens against the reds, the
yellows against the blues, tipping, turning, balancing the fruits as he wan-
ted them to be, using coins of one or two sous for the purpose. He brought
to this task the greatest care and many precautions; one guessed that it was
a feast for the eye to him."

It was not the objects themselves that were meant to gain the viewer's
attention, but the arrangement of colours and forms on the surface, seen
through the artist's own eyes.

This viewpoint, subjectively but deliberately chosen and governed by
the intellect, enabled Cézanne to create a new level of reality on the canvas.
He did not need elaborate objects and sumptuous decoration to do this. On
the contrary, the simplest objects were the best when it came to realizing
his concepts of depth, solidity and weight in a two-dimensional structure.

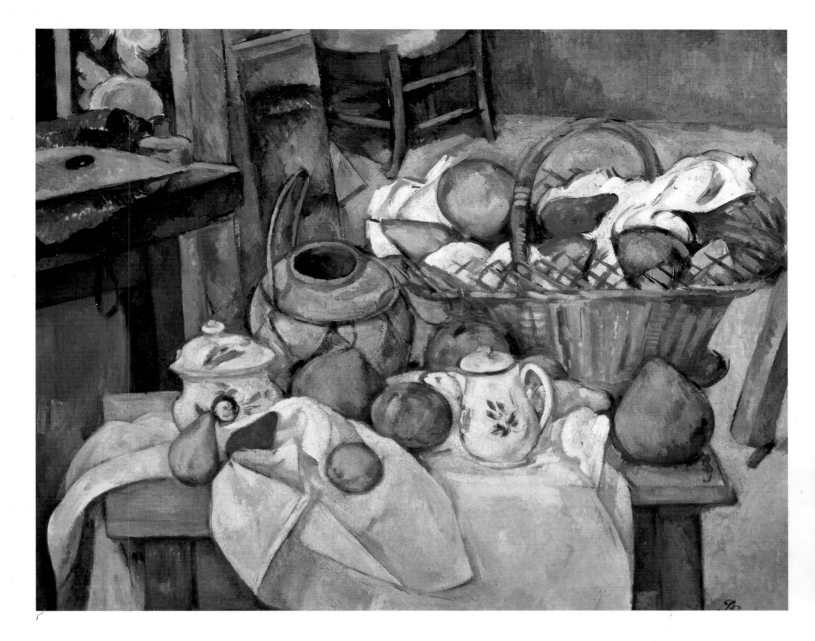

Clearly, compositions like these could not be painted quickly. Cézanne built them up using individual small areas of paint spread across the whole of the canvas, gradually developing these into the form and volume of an object. These areas of paint were tonally balanced with one another, or "modulated", and required a slow and careful style of working. Cézanne would often spend endless amounts of time in front of the canvas without painting a single brushstroke.

Emile Bernard, who recorded his memories of two visits to Cézanne in Aix, wrote of the artist's methods:

"I gained an idea of the slowness of his work when he had installed me in his studio outside the town. While I worked on a still life which he had arranged for me in the downstairs room, I heard him moving back and forth in the upstairs studio. It was as though he was pacing across the room, thinking. He would keep coming downstairs, going into the garden, sitting down and then suddenly rushing back up to the studio. I often surprised him in the garden looking disheartened. He said to me then that I was something of a hindrance to him in his work."

Cézanne constantly reworked his paintings, spending months or – with

Vessels, Basket and Fruit
(The Kitchen Table), 1888–1890
La table de cuisine
Oil on canvas, 65 x 81 cm
Venturi 594; Paris, Musée d'Orsay

What might seem like a random selection of objects is in fact a balanced and carefully thought-out composition. Each object is painted the size which it needs to be to create an equilibrium within the painting.

Basket of Apples, 1890–1894 (detail)
La corbeille de pommes
Oil on canvas, 60 x 80 cm
Venturi 600; Chicago (IL), Art Institute,
Helen Birch Bartlett Memorial Collection

Onions and Bottle, c. 1895–1900
Oignons et bouteille
Oil on canvas, 66 x 81 cm
Venturi 730; Paris, Musée d'Orsay

breaks – years on some of them. But if he found that he could not achieve exactly the balance of colour which he sought, he would simply abandon paintings where they stood, or even destroy the canvas in fury at himself and his lack of success.

The older Cézanne grew, the more he retreated into the solitude of the Jas de Bouffan. "Isolation is what I am worthy of. At least then no-one can get me in his clutches."

His irritability also grew as the result of diabetes, which he had been suffering from since 1890. His complex, sensitive and shy personality made it increasingly difficult for his fellow-beings to get on with him. He would often reject well-meaning gestures from friends and admirers out of fear that they might get too close to him.

Numa Coste, his friend from his youth in Aix, wrote to Emile Zola in the early 1890s:

"[Cézanne] is well and physically solid, but he has become timid and primitive and younger than ever. He lives at the Jas de Bouffan with his mother who, for that matter, is on bad terms with the Ball [Cézanne's wife Hortense], who in turn does not get on with her sisters-in-law, nor they among themselves. So Paul lives on one side, his wife lives on the other.

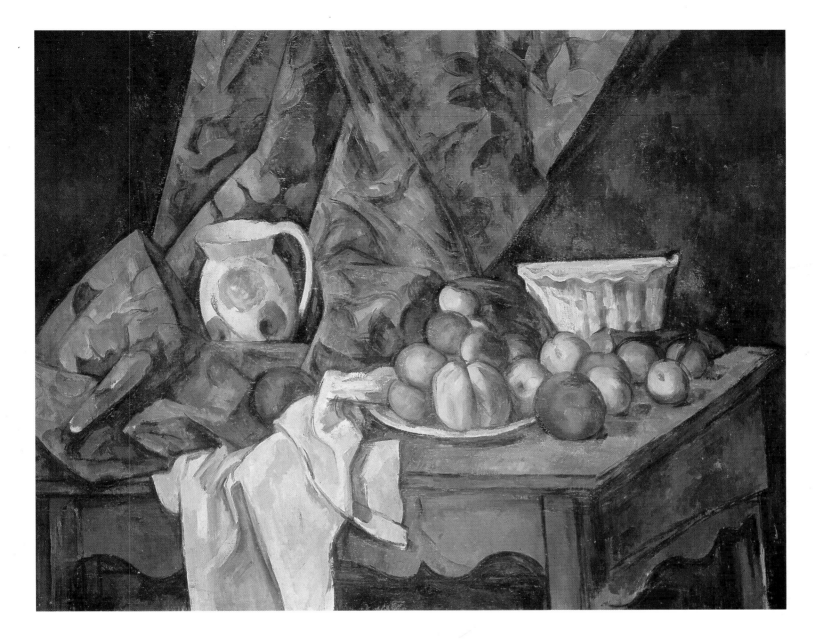

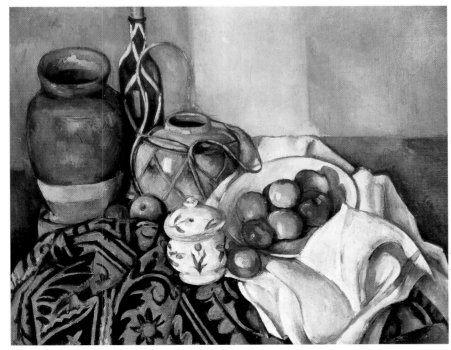

Still Life with Apples and Peaches, c. 1905
Nature morte aux pommes et pêches
Oil on canvas, 81.2 x 100 cm
Washington D.C., National Gallery of Art, Gift of
Eugene and Agnes Meyer

"The pears, peaches, apples and onions, the vases, bowls
and bottles seemed, partly because of the slight
displacements and crooked surfaces, like fairytale
objects which are just about to come to life. And yet it is
clearly the moment before the earthquake, as though
these things are the last."
(Peter Handke, *Die Lehre der Sainte-Victoire*)

Still Life, 1890–1894
Nature morte
Oil on canvas, 65.5 x 81.5 cm
Venturi 598; private collection, on loan to the
Kunsthaus Zürich

Corner of Cézanne's studio on Chemin des Lauves in Aix, with coat stand and still life objects.
Photograph, c. 1930

In 1902, Cézanne moved into the house which had been built for him on the Chemin des Lauves, on a hill to the north of Aix. For the first time, he had a spacious studio in which he could assemble all the objects he used for his still lifes. The ginger jar appears in numerous paintings from the 1890s, as do the straw-cased jar, the jugs and the pitcher. The studio has been preserved largely unchanged today. It was given to the town and Academy of Aix thanks to an American donation in 1954, and since then has been open to the public.

And it is one of the most touching things I know to see this good fellow retain his childlike naiveté, forget the disappointments of the struggle, and obstinately continue, resigned and suffering, the pursuit of a work he cannot produce."

Cézanne had, for some time, been growing increasingly distant from Emile Zola, his closest friend in the early days in Aix and Paris. The warmth of their friendship had cooled considerably. The more comfortable lifestyle which Zola was at last beginning to enjoy as a writer, and his luxurious house in Médan, must have alienated Cézanne, who was still leading a modest and unassuming existence. Cézanne visited Zola many times, often spending several weeks in Médan. But the final break between the two friends came in March 1886 with the publication of Zola's novel, *L'Œuvre*. The novel's protagonist, Claude Lantier, is an artist who fails to realize his ambitions and eventually commits suicide; he bears many resemblances to Cézanne.

The artist's pride must have been considerably wounded. His letter to Zola thanking him for sending a copy of the novel is very formal, distant and polite:

"My dear Emile,

I have just received *L'Œuvre*, which you were good enough to send me. I thank the author of *Les Rougon-Macquart* for this kind token of remembrance and ask him to permit me to clasp his hand while thinking of bygone years.

Ever yours under the impulse of past times.

Paul Cézanne."

This was the last letter in the long correspondence between Cézanne and Zola.

In the 1890s, Cézanne continued to paint landscapes in and around the Jas de Bouffan, as well as still lifes and portraits. He often painted portraits of himself – his most patient model! For others, the endless sittings were often torture. Cézanne demanded that his models remain absolutely motionless, posing almost as though they were objects in his still lifes. To him, a head was no different from an apple as the basis for a composition; for Cézanne was not interested in the emotions or individual personalities of any of the people whose portraits he painted.

For this reason, he tended to paint the kind of people whom he could afford to pay as models, such as the farmers and day labourers on the tenanted fields of the Jas de Bouffan. It was people like those who were used as the models for *The Card Players* (1890–1892, ill. p. 63), of which he painted five different versions. He may have been led to use this motif by the anonymous painting of the same name in the Musée Granet in Aix, which is reputed to have been one of his favourite paintings within the museum.

These compositions were based on detailed pencil, watercolour and oil studies. In successive paintings, the number of card players was gradually pared down to two, almost resembling a still life. Cézanne's *Card Players* are very far from being genre pieces, despite the fact that they show scenes from everyday life – the sturdy local peasant figures playing their beloved belote. Unlike the cheerful *joie de vivre* of Renoir's *Le Moulin de la Galette*, and more like Van Gogh's *The Potato-Eaters* of 1885, these paintings express the harsh melancholy of the Provençal countryside and its inhabitants. Their faces are serious, their shoulders seemingly weighed down by life's burdens. In the version with four card players, the cool, pale blue daylight is the dominant colour. The players' hands and faces are painted in a warm orange tone, suggesting concentration and inner tension amid all the

external tranquillity. This orange tone is taken up by the rumpled curtain in the top right-hand corner of the picture, with the motif of the pleated folds being extended down to the bottom edge of the picture by the right-hand player's peasant smock. The blue of the smock provides a cool contrast with the warm complementary orange of the curtain. The purpose of the curtain is purely compositional; it is not used to define the space as, say, a café outside Aix. Rather it helps to fix the composition in space, which is something the pastel blue wall does not do because of its lack of spatial determination. In addition, together with the pipe rack on the wall, the curtain creates a link with the standing onlooker as he concentrates on passively watching the game.

The composition used in the version of *The Card Players* with two players (1890–1892, ill. p. 64) is very different. Here the background is mainly dark, and only a few light-coloured strips give an idea of the space, perhaps the roofed terrace of a café. The scene is lit by artificial light, which is reflected on the tablecloth, bottle and pipe. Here again, the purpose of the painting is not to re-create some everyday scene from small-town provincial life, but to solve the compositional problem of depicting people in space. The two men sit stiffly at the table, its edges receding into the

The Card Players, 1890–1892
Les joueurs de cartes
Oil on canvas, 65 x 81.7 cm
Venturi 559; New York, The Metropolitan Museum of Art, Gift of Stephen C. Clark

Cézanne wholly avoids any narrative, genre-like element which a motif of this kind could have contained and instead builds up a painting in accordance with strict rules of colour and form. This emphasizes the simple dignity of the ponderous Provençal day-labourers, who worked at the Jas de Bouffan and were paid to sit for Cézanne.

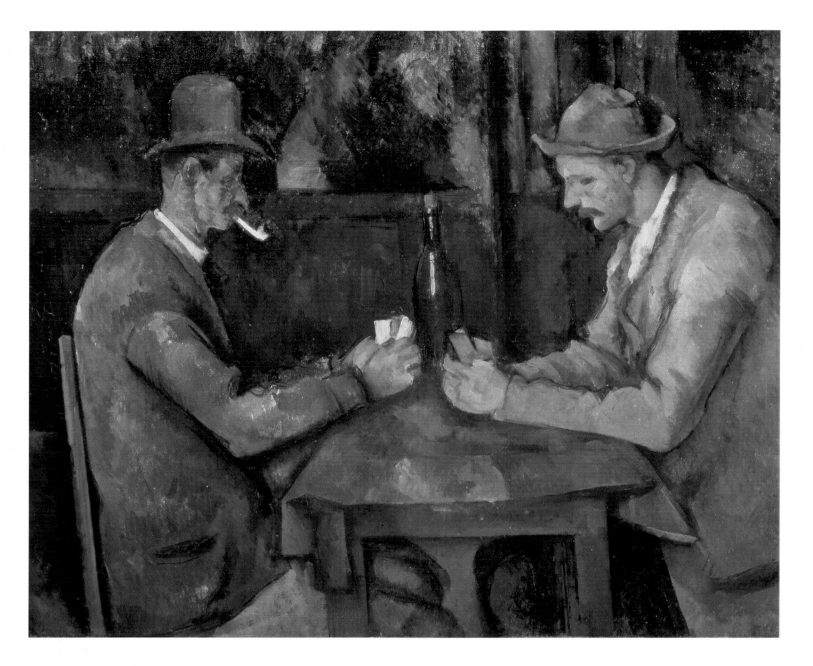

The Card Players, 1890–1892
Les joueurs de cartes
Oil on canvas, 45 x 57 cm
Venturi 558; Paris, Musée d'Orsay

ILLUSTRATION PAGE 65:
The Gardener, 1900–1906
Le jardinier
Oil on canvas, 63 x 52 cm
Venturi 715; London, Tate Gallery

background and culminating in the vertical axis with the bottle. The table is the centre of the scene; it is the meeting-point for the diagonals of the players' bent arms, as well as the focus of their gaze. The table is fully lit, and its warm orange tone provides a transition between the dull, cool bluish-grey of the left-hand player and the pale grey of the man on the right. Both the men's jackets contain echoes of the colour of the table.

Every detail in the painting serves a purpose and contributes to the overall effect. Nothing is left to chance. Far from painting a naturalistic or anecdotal scene, Cézanne has succeeded in creating a carefully thought-out composition of directional values and relationships between colours and forms. It is a monumental, and yet intimate scene.

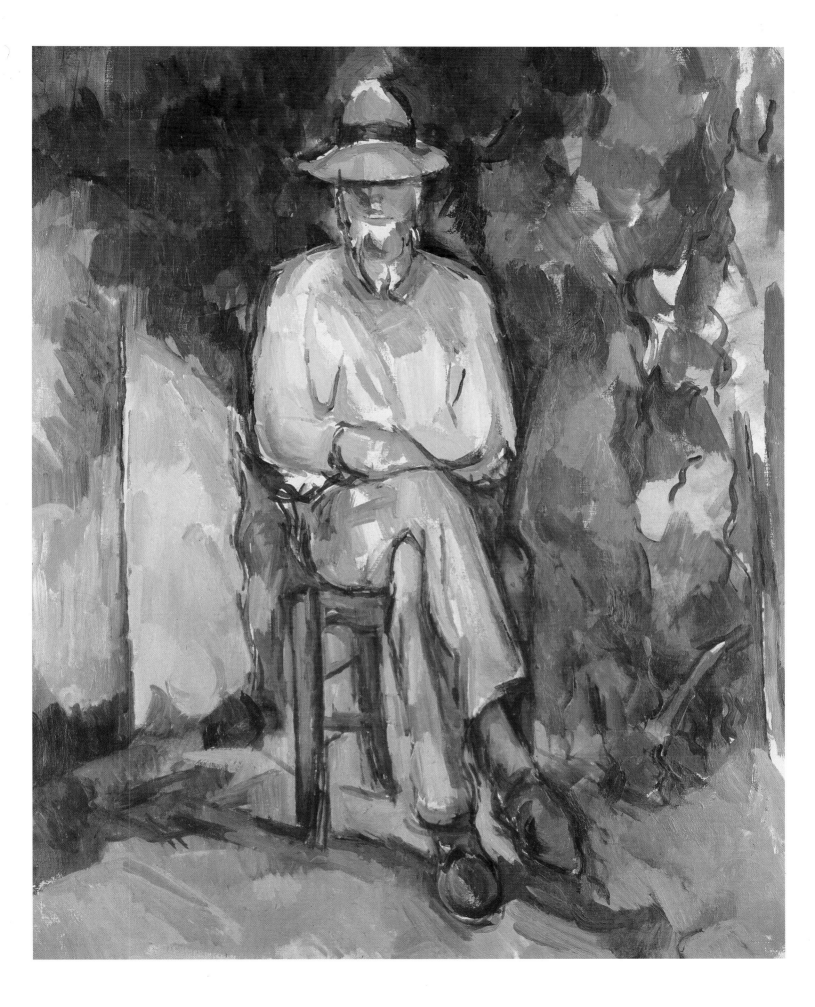

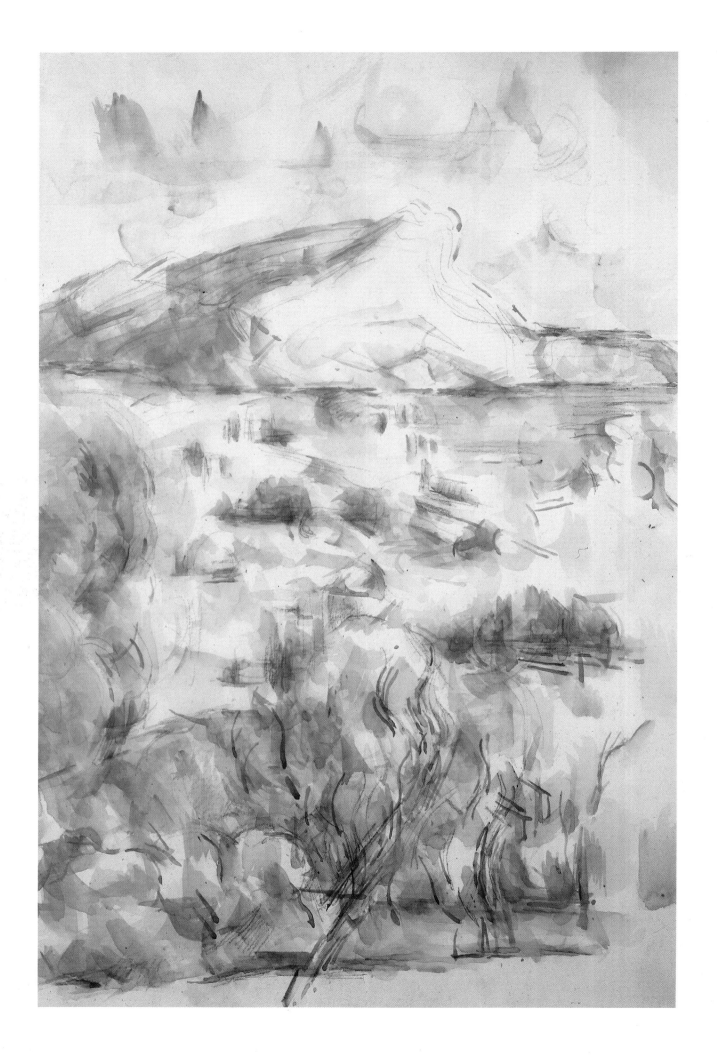

The Painter and his Mountain – Mont Sainte-Victoire

During the 1890s, Cézanne spent most of his time in Aix, though making frequent journeys to Paris. But the Provençal landscape had captivated him like no other. In the summer of 1896, which he spent in a health resort at Talloires on Lake Annecy, he wrote to his friend from his youth, Philippe Solari:

"When I was in Aix, it seemed to me that I should be better elsewhere; now that I am here, I miss Aix. Life for me is beginning to be of a sepulchral monotony... I paint to divert myself; it is not very amusing, but the lake is very nice with the big mountains all round... I have been told that they are two thousand metres high; it is not worth our country, though – without exaggeration – it is fine. But when one was born down there, it is no use, nothing else seems to mean anything."

Nevertheless, *Lake Annecy* (1896, ill. p. 68) is one of the most impressive of all the landscapes which Cézanne painted outside Provence. The surface of the water appears dense and impenetrable; its effect is motionless and tec-tonic, like that of the mountain which stands immediately behind it, a great, solid mass.

Cézanne constructed this painting using the information about colours and forms which he absorbed as he looked at the motif; the *sensations colorantes* perceived with his eyes, the prime outlet of his personality. He painted what he saw, and not what he knew. He saw nature in its raw, primaeval state, transmuting what he saw into a new reality borne of his own perceptions; he "realized" nature anew.

Cézanne once described his way of perceiving nature to the author Joachim Gasquet. He used the image of spread and closed fingers to explain his manner of reproducing a motif.

"This is what one must achieve. If I reach too high or too low, everything is a mess. There must not be a single loose strand, a single gap through which the tension, the light, the truth can escape. I have all the parts of my canvas under control simultaneously. If things are tending to diverge, I use my instincts and beliefs to bring them back together again... Everything that we see disperses, fades away. Nature is always the same, even though its visible manifestations eventually cease to exist. Our art must shock nature into permanence, together with all the components and manifestations of change. Art must make nature eternal in our imagination. What lies behind nature? Nothing perhaps. Perhaps everything. Everything, you understand. So I close this errant hand. I take the tones of colour I see to my right and my left, here, there, everywhere, and I fix these gradations, I bring them together... They form lines, and become objects, rocks, trees, without my thinking about it. They acquire volume, they have an effect. When these masses and weights on my canvas correspond to the planes,

Emile Bernard:
Paul Cézanne on the hill at Les Lauves in Aix, 1904
Photograph

ILLUSTRATION PAGE 66:
***Mont Sainte-Victoire**, **Seen from
Les Lauves***, 1902–1906
La montagne Sainte-Victoire
Watercolour, 48 x 31 cm
Philadelphia (PA), Philadelphia Museum of Art, Gift of Mrs Louis C. Madeira

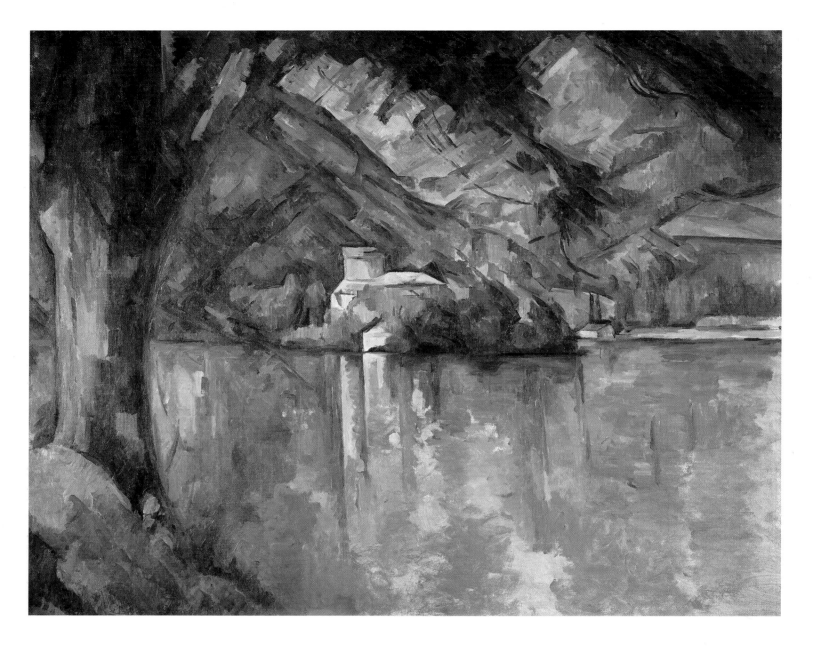

Lake Annecy, 1896
Lac d'Annecy
Oil on canvas, 64 x 79 cm
Venturi 762; London, Courtauld Institute
Galleries

Cézanne thought Lake Annecy, with its
dramatic mountain surroundings, was almost
too picturesque, suited "to drawing exercises
for young Englishwomen". In his hands, the
lake becomes an opaque area of colour, and
the sides of the mountains are tectonic
masses.

and spots which I see in my mind and which we see with our eyes, then
my canvas closes its fingers. It does not waver. It does not reach too high
or too low. It is true, it is dense, it is full... But if I have the slightest dis-
traction or feel the slightest weakness, particularly if I start reading too
much into things, if I am swept along by a theory today which contradicts
yesterday's, if I think when I am painting, if I interfere, then bang, every-
thing slips away."

This newly created reality is centred on permanence and stability. It is
very different from the temporal, unstable "Sunday celebration of the
moment" which the Impressionists created in their paintings.

Cézanne's mother died in 1897. He had looked after her with great de-
votion during her final years, when she was frail and in need of care and
attention. In order that her estate could be divided between the three chil-
dren, the Jas de Bouffan, Cézanne's home for so many years, was sold. It
is not known why Cézanne agreed to the sale; he could have afforded to
buy out his sisters. The property may have been too large for him on his
own, and his wife and son were living in Paris for most of the time. So
Cézanne left the house, with its salon still containing the murals he had
painted in his youth, with its grounds and magnificent avenue of chestnut

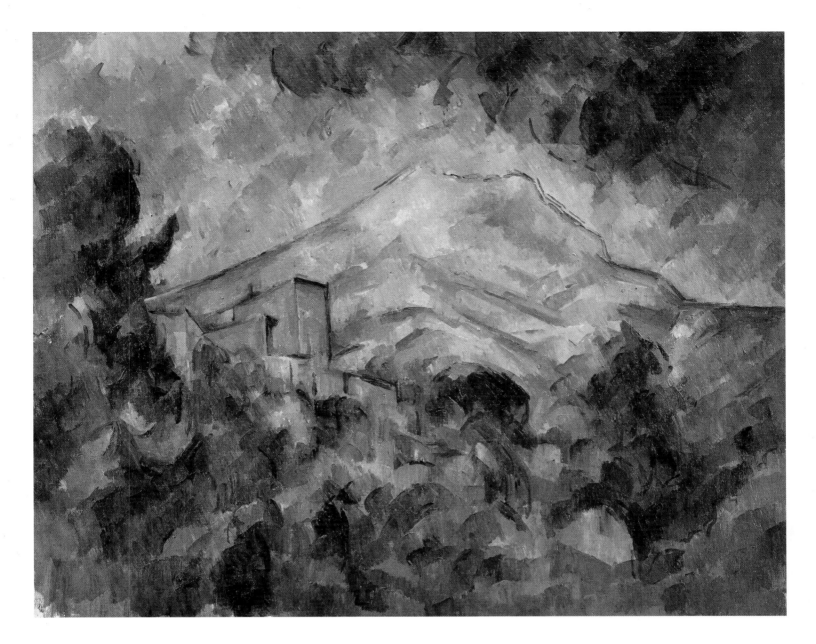

trees, its old trees and its view of Mont Sainte-Victoire. He moved into an apartment in the centre of Aix, in the Rue Boulegon, and took on a house-keeper, Madame Brémond. "I am under orders not to touch him," she told Cézanne's friend and biographer Emile Bernard, "not even with my dress when I go past him."

Some years before, Cézanne had rented a small cottage near Bibémus quarry to the east of Aix to make it easier for him to paint in the open air, and he now began using this. He also rented a room in the Château Noir, an estate halfway to the village of Le Tholonet on the way to Mont Sainte-Victoire, where he could store his painting equipment.

The "black castle" was in fact a reddish roughcast neo-Gothic building belonging to a coal merchant who had come into some money. This was the place where Cézanne produced many of his late paintings; surrounded by pine forests, with the ochre-coloured stone of Bibémus quarry nearby and a view of the towering rockface of Mont Sainte-Victoire.

The mountain, a massive limestone ridge around a thousand metres high, fascinated Cézanne all his life and it provided an inexhaustible source of new compositions.

The early works containing mountain motifs include *The Great Pine*

Mont Sainte-Victoire and Château Noir, 1904–1906
La montagne Sainte-Victoire et le Château Noir
Oil on canvas, 65.6 x 81 cm
Venturi 765; Tokyo, Bridgestone Museum of Art, Ishibashi Foundation

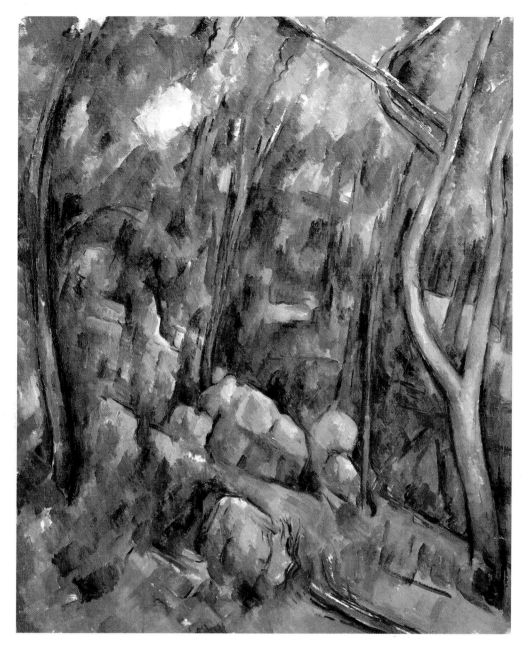

In the Grounds of Château Noir, c. 1900
Dans le parc du Château Noir
Oil on canvas, 93 x 74 cm
Venturi 787; London, National Gallery

The transformation and resolution of objects into areas of colour is a feature of Cézanne's later works. This view of painting no longer requires dramatic motifs: a randomly chosen detail of landscape containing tree trunks, foliage and block-shaped rocks suited Cézanne's distinctive ideas of pure painting just as well as the Château Noir or Mont Sainte-Victoire.

(Mont Sainte-Victoire) (1886–1887, Phillips Collection, Washington D.C.). Here, the mountain has not yet become the dominant motif in the painting but is an integral part of the landscape. The eye is led along the valley of the river Arc and its railway viaduct towards Mont Sainte-Victoire.

The landscape is framed by the trunks and branches of two stone pines serving as a foreground motif. Their flowing contours neatly follow those of the mountain itself, and the pale green of the valley floor, interspersed with patches of yellow ochre, is just as intense in the background as it is in the foreground.

The Great Pine has distance rather than any real depth; it is not three-dimensional in the traditional sense. Even the mountain, the most distant object in the picture, is darkly outlined, giving it a clear structure and spatial orientation. It is positioned above rather than behind the fields, between the valley floor and the stone pine branches.

As is so often the case with Cézanne's paintings, it is impossible to say what time of day, or what season, this picture depicts. The evergreen vegetation, the even, passionless light and the understated atmosphere make it

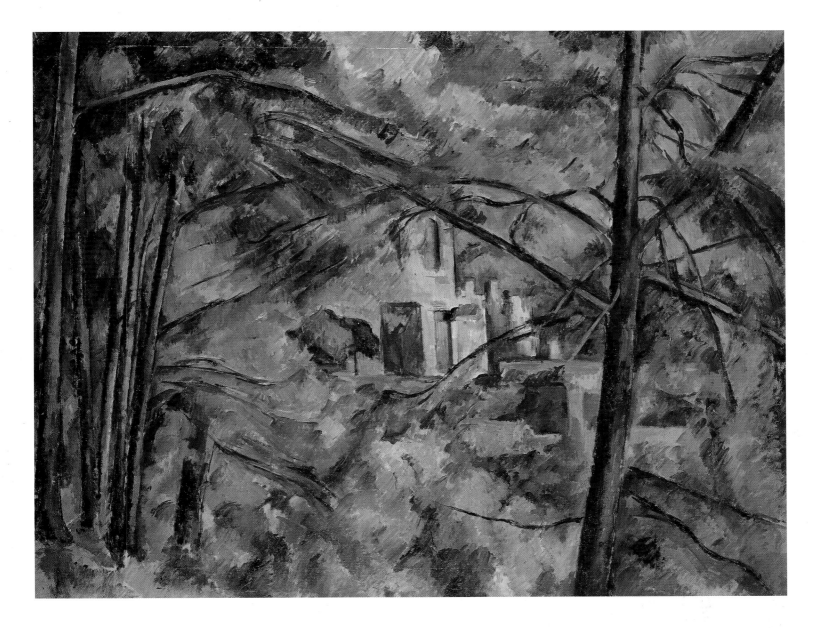

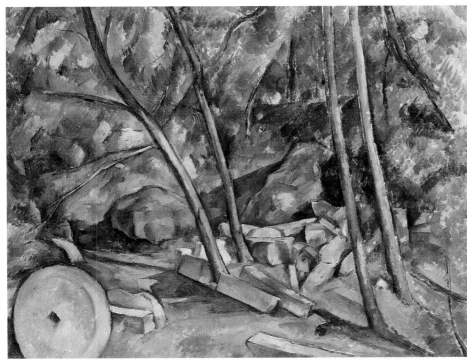

***View of Château Noir**, 1894–1896*
Vue de Château Noir
Oil on canvas, 73 x 92 cm
Venturi 667; Washington D.C., National Gallery of
Art, Gift of Eugene and Agnes Meyer

Cézanne depicts the "Black Castle", popularly
believed to be a place where Satanic rituals were
held, as a mysteriously glowing building hidden
behind dense foliage.

***The Mill**, 1898–1900*
La meule
Oil on canvas, 73 x 92 cm
Venturi 768; Philadelphia (PA), Philadelphia Museum
of Art, Collection of Mr and Mrs Carroll S. Tyson, Jr.

An oil mill was to have been built near the Château
Noir, but this project was never completed. The
stones which were left lying around, half-covered in
vegetation, provided a motif for Cézanne. They en-
abled him to create a harmonious relationship between
cool and warm colours and between geometric and
organic forms.

Quarry at Bibémus, 1898–1900
Carrière de Bibémus
Oil on canvas, 65 x 81 cm
Venturi 767; Essen, Museum Folkwang

In the 1890s, Cézanne found new subjects
east of Aix: the Château Noir and the quarry
at Bibémus, whose reddish-ochre shell
limestone had been used for building since
Roman times. The strength of the painting
comes from its chaotic jumble of rock faces
drenched in sunlight. So powerful is their
colour that it is even reflected by the sky.

impossible to ascribe it to a particular moment. It is as though Cézanne has
removed any distractions which could make the subject of the painting
unclear in any way, so that the reality of nature can speak for itself. This
reality is not the reality of the moment, of a momentary "being thus", but
rather one which embodies the experience of immutability and permanence,
of simply "being there". This is what Cézanne meant when he said that he
wanted to make Impressionism into something permanent, like art in
museums.

Cézanne passionately directed all his efforts towards this end. He once
said to Joachim Gasquet:

"Impressionism, what does it mean? It is the optical mixing of colours,
do you understand? The colours are broken down on the canvas and re-
assembled by the eye. We had to go through that. Monet's *Falaises* will
always be a wonderful series of pictures, and so will a hundred other works
by him... He has painted the gleaming iris of the earth. He has painted
water... But now we need to give a firmness, a framework, to the evan-
escence of all things, and to these pictures by Monet."

Cézanne's concept of a fixed structure should not be understood as
depicting nature where time has stood still, frozen in a particular moment.
He is not trying to bring fixity to the paintings of the Impressionists.

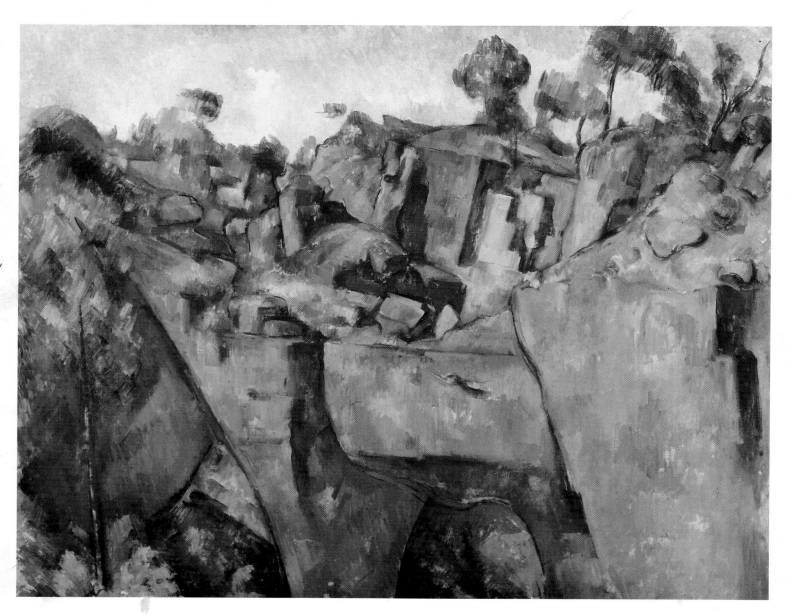

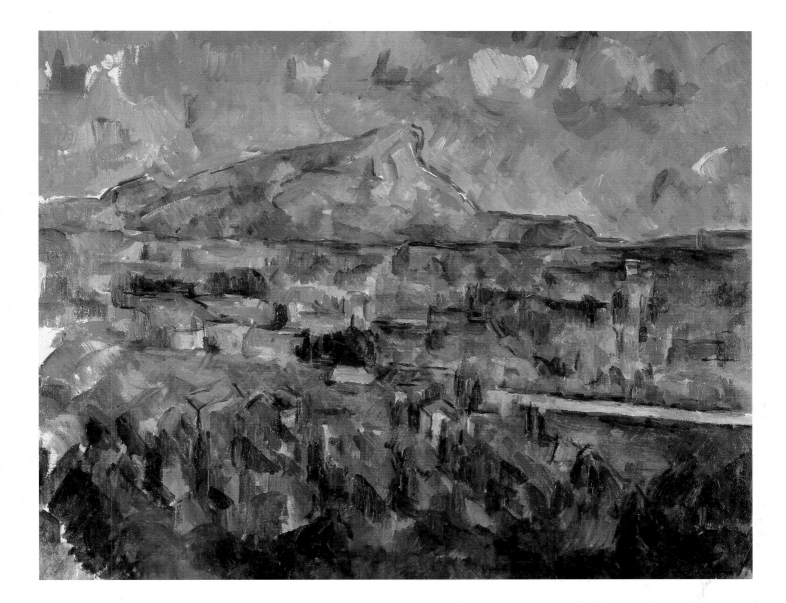

Mont Sainte-Victoire, 1902–1906
La montagne Sainte-Victoire
Oil on canvas, 65 x 81 cm
Philadelphia (PA), Philadelphia Museum of Art

gravel path or a rock will absorb the colour of the surrounding vegetation and the sky, and glow with it.

In the Basle painting of *Mont Sainte-Victoire, Seen from Les Lauves* (1904–1906, ill. p. 75), Cézanne uses an intense blue to depict light. It is a transcendently atmospheric colour, which also makes a brief appearance amid the shadows in the foreground, as though part of the light were breaking through the yellow ochre and green of the ground.

The shadow on either side of the brightly lit area is painted in dark violet tones mixed in with red and green. These are predominantly warm tones, creating a contrasting tension with the cool blue of the mountain. They also seem to be closer to the viewer, whereas the blues appear to be further away.

Cold and warm colours, closeness and distance are interwoven. But despite these inherent contrasts and tensions, the picture of Mont Sainte-Victoire is a balanced and self-contained framework of colours and forms. Change and permanence, order and flexibility are combined to create an extraordinary, virtuoso form of dynamic equilibrium.

In the Zurich version of *Mont Sainte-Victoire, Seen from Les Lauves* (1904–1906, ill. p. 76), Cézanne has left areas of the composition unpainted and white. These may be areas which he has not sufficiently worked out in his mind; perhaps he has not yet managed to find the right colours for what were effectively areas of "no-man's land".

Although Cézanne's fellow artists – Monet, Pissarro, Sisley, Renoir – were showing an increasing appreciation of his work, his own emotions still fluctuated wildly between euphoria, depression and, in some cases, despair.

In the spring of 1895 he asked the art critic Gustave Geffroy to sit for a portrait. After three months of daily sittings he gave up on the painting, saying apologetically to Geffroy that he had taken on too much, and returned despondently to Aix.

The same year, however, brought Cézanne a personal triumph: the young art dealer Ambroise Vollard opened an exhibition of some fifty of his paintings in December 1895.

Vollard, who had his gallery in Rue Laffitte, had developed links with Cézanne through the artist's son Paul, now aged twenty-three. Paul was increasingly taking care of his father's business affairs and regularly sold paintings by Cézanne to Vollard, receiving an agency fee of ten per cent from both parties. "The boy is much smarter than I am," Cézanne said admiringly of his son, "I have no practical sense." Cézanne did not grow rich from the sale of the paintings, but Vollard did at least guarantee to take all of them, including those which were unfinished or damaged.

The art critic Gustave Geffroy wrote an article in praise of the exhibition at Vollard's gallery. "Passers-by walking into the Galerie Vollard, in Rue Laffitte, will be faced with about fifty pictures: figures, landscapes, fruit, flowers, from which they can finally reach a verdict on one of the finest and greatest personalities of our time. Once that has happened, and it is high time that it did happen, all that is dark and legendary about Cézanne's life will disappear, and what remains will be a rigorous and yet attractive, masterly and yet naive life's work... He is a great fanatic for the truth, fiery and naive, austere and subtle. He will end up in the Louvre."

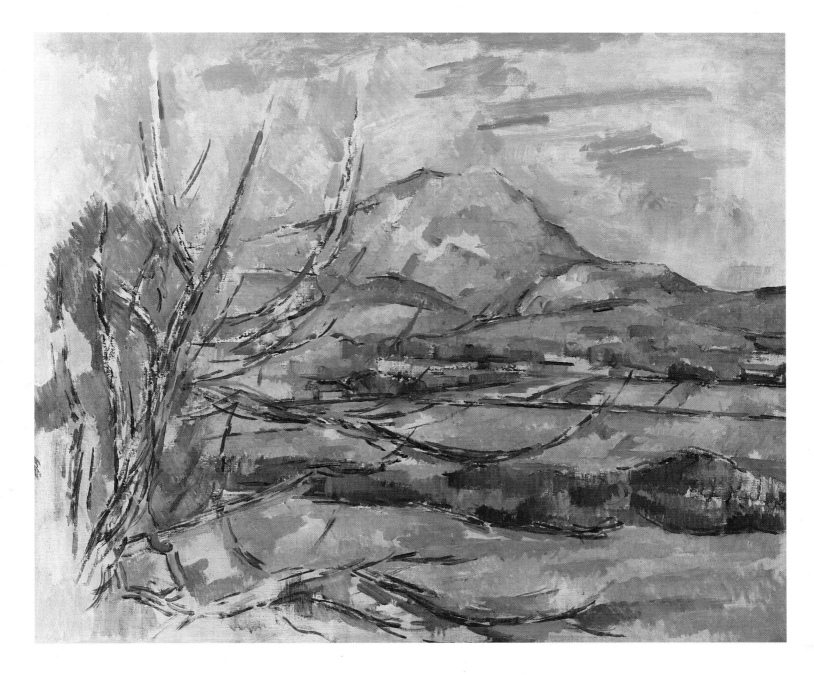

Mont Sainte-Victoire, 1890–1894
La montagne Sainte-Victoire
Oil on canvas, 54 x 65 cm
Venturi 661; Edinburgh, National
Gallery of Scotland

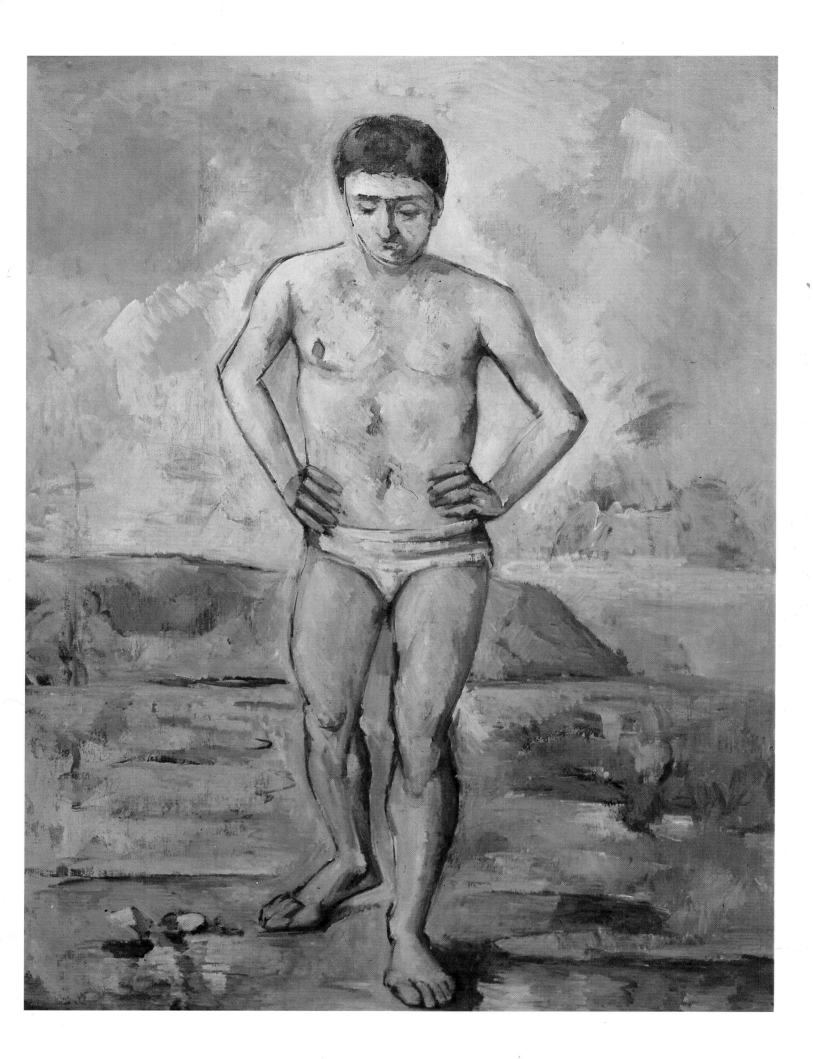

The Bathers – The Latter Years

After the Vollard exhibition, collectors became increasingly interested in Cézanne, and his paintings began to fetch significant prices at auction. Zola's collection was auctioned in September 1902 after his death from smoke poisoning, and one early picture, *The Abduction*, achieved a record price of 4,200 francs. A landscape by Monet, who was a much more respected artist, fetched only 2,805 francs.

But the majority of the press and public still had little sympathy for this new way of depicting nature. After the auction of Zola's paintings, a malicious article in *L'Intransigeant* strongly criticized both Cézanne and Zola as those "who propagated this madness with the brush". The article, by Henri Rochefort, a rival of Zola, provided further grist to the mill of public opinion in Aix; thousands of copies of *L'Intransigeant* were sent to Aix and distributed among conservative art lovers. Cézanne and his family received threatening letters, and the artist came more under fire than ever before from small-minded citizens who ideally would have liked to hound the eccentric banker's son out of town.

During the years that followed, Cézanne took part in an increasing number of exhibitions. He had three paintings on display at the Salon des Indépendants and the Paris World Exhibition in 1900, and his fame spread to neighbouring countries; the Berlin Nationalgalerie was the first gallery to acquire one of his paintings. He exhibited at the Vienna Secession and in Brussels and had a room to himself at the newly established Autumn Salon of 1904, containing thirty-three of his paintings.

Cézanne worked unstintingly. After the sale of the Jas de Bouffan, all that he had left was his small temporary studio in the Rue Boulegon and the rented rooms in the Château Noir. He tried to buy the château, but his offer was turned down by the owner. He therefore bought a plot of land on the Chemin des Lauves, on an otherwise undeveloped hillside to the north of Aix, and had a two-storey house built with a large studio, some five metres high, on the first floor. The outer wall of the studio had a long, narrow slit in it so that large canvases could be pushed through it (ill. p. 88).

Cézanne moved into this house in 1902, but kept his apartment in the Rue Boulegon. He only ever went into his studio to paint, which he usually did early in the morning and then again in the late afternoon. When it became too hot, he would paint watercolours on the terrace, which was surrounded by bushes and small trees and had a magnificent view of the town of Aix. From time to time, local agricultural workers or his gardener Vallier would sit for him, for example for his painting *The Gardener* (1900–1906, ill. p. 65).

During the last years of his life, Cézanne set himself another objective. He decided to devote a number of large compositions to a motif he had

Anonymous:
Standing model, undated
Photograph
New York, The Museum of Modern Art

ILLUSTRATION PAGE 80:
Man Standing, Hands on Hips, 1885–1887
Le grand baigneur
Oil on canvas, 127 x 96.8 cm
Venturi 548; New York, The Museum of Modern Art, Lillie P. Bliss Collection

Cézanne preferred using photographs or sketches rather than nude models because he felt uncomfortable in their presence. This painting, too, is based on a photograph. It is unusual for one of Cézanne's bathers to dominate the picture as much as this one does.

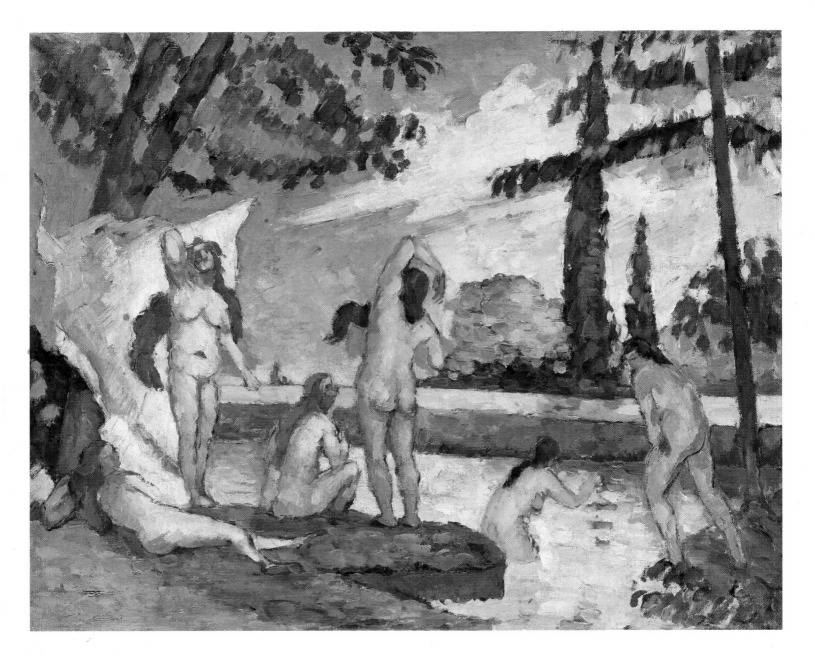

Bathers, c. 1875–1877
Baigneuses
Oil on canvas, 38.1 x 46 cm
Venturi 265; New York, Metropolitan
Museum of Art, Joan Whitney Payson
Foundation

Cézanne has avoided individualizing his
figures: his interest lies in creating an artistic
harmony between the figures and the land-
scape rather than in the figures themselves.
The expressive distortions of forms influ-
enced other painters of the time, and particu-
larly the Fauvists.

painted at the beginning of his career as an artist: semi-abstract figures in
a landscape.

Now, aged over sixty, Cézanne recalled the most carefree and happy
time of his life when he would go out with his friends Zola and Baille,
exploring the area around Aix and spending many hours on the banks of the
river. He produced many drawings, watercolours and oil paintings of these
bathing scenes, calling them *Idyll*, *Nudes on the Riverbank* or simply
Bathers. In all, he produced some 140 drawings, sketches and paintings
depicting this motif.

But it was not just the personal memories of his youthful friendship that
spurred Cézanne to produce so many of these works. The reasons lay even
deeper than that: Cézanne had a great respect for the Classical painters of
Arcadian idylls who sought to unite man and nature in perfect harmony.
"Imagine Poussin wholly reclaimed from nature," he said to Gasquet. "That
is the Classicism which I am striving to achieve." However, Cézanne sought
his harmonies not in the artificial forms of the ancients, as had the old
masters whom he so much admired, but in nature itself, which reveals its
richness of colour to the close, open-minded observer.

But the results on canvas still fell far short of Cézanne's inner perceptions. He never really achieved his aim; he could only ever come close to it, and life was a constant process of struggling and searching. In 1906, five weeks before his death, he wrote to his son:

"Finally, I would like to say to you that as a painter I am becoming more clear-sighted in the face of nature, but it is always very hard for me to realize my perceptions. I cannot achieve the intensity which evolves before my eyes; I do not have that wonderful richness of colour which animates nature. Here, on the bank of the river, there are many different motifs; the same subject, seen from a different angle, offers an extremely interesting subject for a study, and one of such complexity that I believe I could work on it for months without changing my position, simply by looking first to the right, and then to the left."

When he painted his figures in landscapes, Cézanne used the many studies he had made since the beginning of his career as an artist. Some of these came from the Ecole des Beaux-Arts in Aix, where life drawing was obviously part of the course, or the Académie Suisse in Paris, where he regularly drew from the model. The most important sources of inspiration were his repeated visits to the Louvre, where he made pencil studies of paintings by Delacroix, Rubens, Raphael, Veronese, Michelangelo and Poussin, as well as of Classical, Renaissance and Baroque sculptures.

Cézanne made frequent use of these sketches, along with illustrations from his sisters' fashion magazines and, when he painted figures, reproductions from books. Francis Jourdain mentions an album entitled *Le Nu au Musée du Louvre*, containing distinctly mediocre illustrations, which

Invitation to the second exhibition of Cézanne's work by the art dealer Ambroise Vollard, May 1898.

Six Women, 1892–1894
Le bain
Oil on canvas, 27 x 41 cm
Venturi 588; Moscow, Pushkin Museum

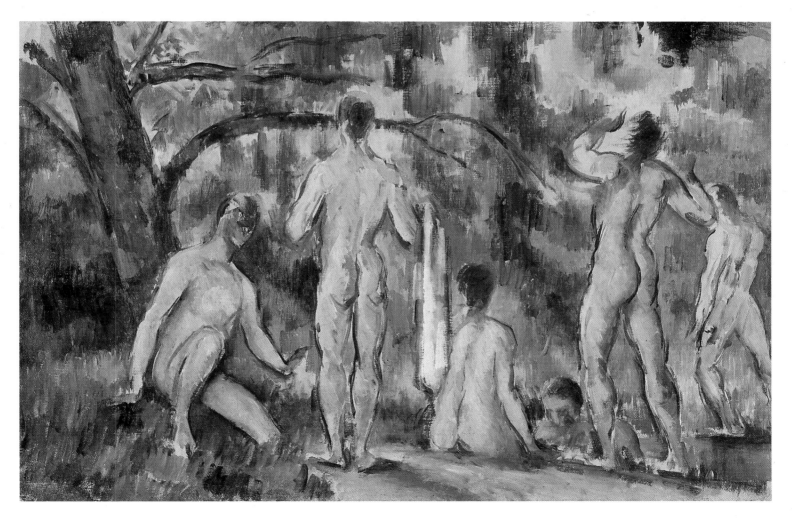

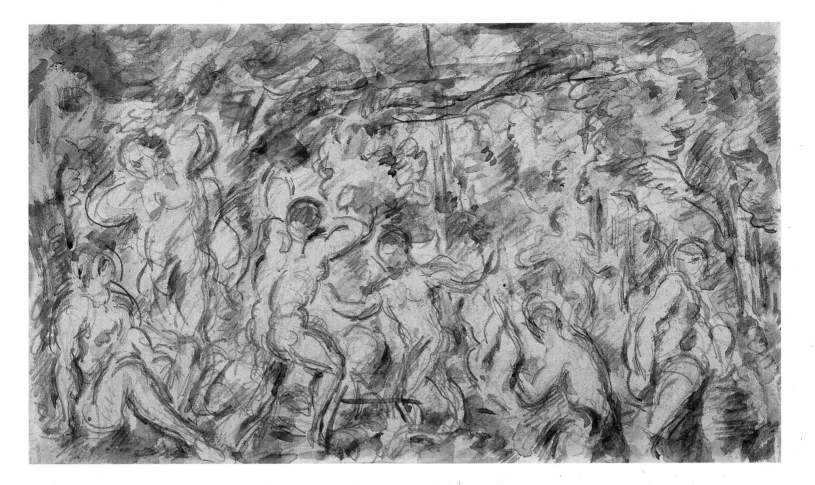

Bathers, c. 1900
Baigneurs
Watercolour and pencil, 13 x 21 cm
Venturi 1112; Tokyo, Bridgestone Museum
of Art, Ishibashi Foundation

The figures of the eight male bathers in this
scene have merged into one with the lively
background of vegetation.

Cézanne bought from a street kiosk in Paris. Obviously Cézanne could not
draw without a model, and he very often used sources such as these, de-
spite their poor quality. But drawing was never any more than a means to
an end, used to sketch out an idea or create the external form of a figure in
motion. The lines and forms of these pictures derived solely from colour.

He even regarded the Louvre purely as a source of information, "a good
reference work". Cézanne regarded nature as the true teacher, with all its
infinite variety of phenomena; it was nature that was mainly deserving of
study. But it was also possible to learn from the Classical artists, and par-
ticularly the Venetians. "It does not matter which of them you prefer," he
told Joachim Gasquet, "he should simply provide you with direction. Other-
wise you are an imitator. If you have a feel for nature, however it is ac-
quired, and a few good ideas, you are bound to achieve your own freedom;
you must not let other people's advice and methods change your own way
of seeing things."

The theme of the bathers in Cézanne's work can be traced back to the
beginning of the 1870s. Male and female bathers rarely appear together in
the same painting, and these works are therefore very different from the
dramatic pictures of the 1860s and early 1870s, in which Cézanne used the
confrontation between the sexes in a provocative way. This is probably the
result of Cézanne's strong feeling of shame, his sexual inhibitions and
fears, and his shyness about showing naked men and women together in
what he regarded as trivial, sensual poses.

Cézanne's aim in strictly segregating the sexes in the *Bathers* series was
to exclude any connotations from the situation, any element of the tran-
sient, sensual or erotic. This meant that his figures became internalized,
spiritual beings, and he could concentrate wholly on the purely formal,

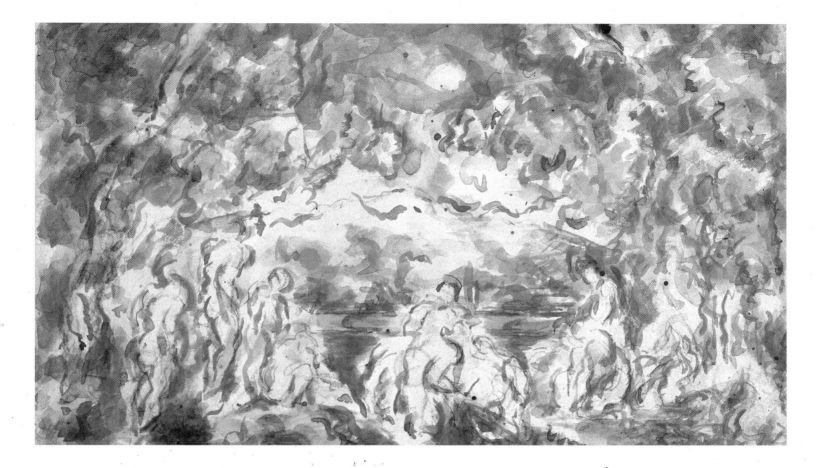

compositional problems of his pictures because they had been freed of content.

Cézanne painted numerous watercolours on this theme. In the sheet from a sketch album, *Bathers* (c. 1900, ill. p. 84), six of the men are clearly visible, and two more, on the right of the picture, are suggested by a few curved outlines. These have melted into the background, which is full of movement, and are therefore at one with nature. It is a turbulent scene, and includes the motif of the figure folding its arms behind its head which appears in nearly all the pictures of bathers. It is a gesture of relaxation, of opening oneself up and offering oneself. In this particular case it is presenting an erection to the seated figure in the bottom left-hand corner.

The small page of *Bathers* (1900–1906, ill. p. 85) also comes from one of Cézanne's sketchbooks. It is a watercolour version of an oil painting, with an arch-shaped background of vegetation. Alternatively, this may have been a study for what is probably Cézanne's best-known painting on this theme, *The Large Bathers* (1898–1905, ill. p. 89), now in the Philadelphia Museum of Art. The conical outline in the background may represent Mont Sainte-Victoire, though this is not certain.

Here again, the figures and vegetation are closely interwoven. The picture is a delicate, highly complex tissue of bold brushstrokes, spots of paint and transparent areas of colour. The forms are extremely lively and varied; light, open and insubstantial. The group of bathers and the vegetation have merged into a unity in which time no longer seems relevant. The picture seems to be expressing Cézanne's longing for an existence which is in harmony with nature, and in which humans bear strong affinities with the plant world that surrounds them.

There are few colours: a transcendent blue, bordering on violet, and a

Bathers, 1900–1906
Baigneuses
Watercolour and pencil, 13 x 21 cm
Venturi 1108; private collection

Page from a sketchbook; the layout of the landscape and the groups of figures bear similarities to the version of *The Large Bathers* in the Philadelphia Museum of Art. Cézanne believed that the bathers should become a part of the overall structure of the picture, echoing the rhythm of the trees, the sky and the water.

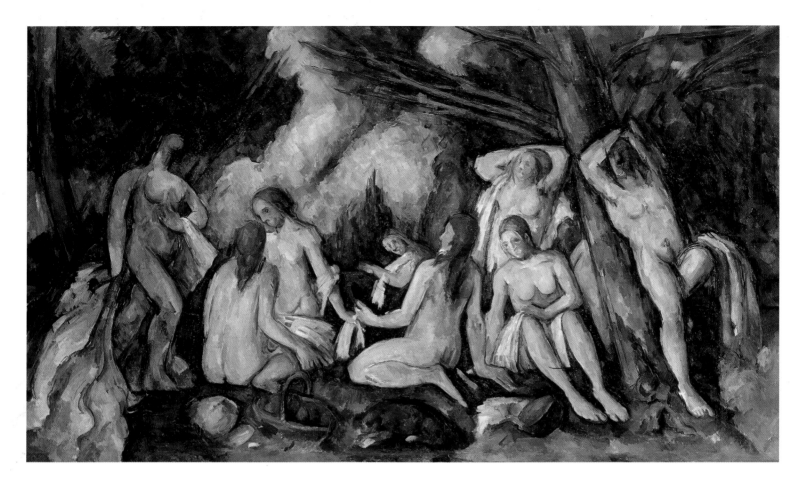

The Large Bathers, 1900–1905
Grandes Baigneuses
Oil on canvas, 133 x 207 cm
Venturi 720; Merion (PA), The Barnes
Foundation

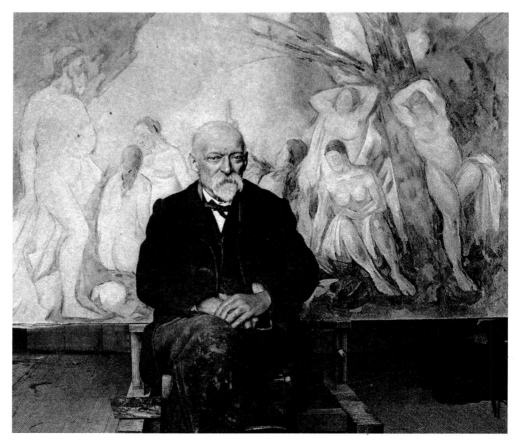

Cézanne in front of *The Large Bathers*,
photographed in 1904 by Emile Bernard in
Cézanne's studio on Chemin des Lauves.

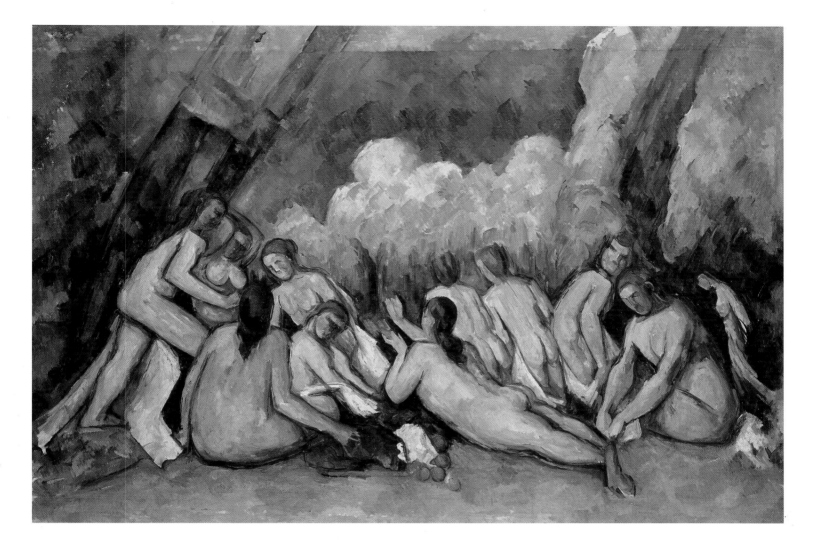

yellow which verges on yellow ochre and is mixed with the blue in the areas of foliage to create a light green. But these combine with the pale background of the paper to create a very subtle and harmonious composition. The two groups of bathers on either side of the picture are not isolated from each other; they are enclosed by a natural stage, and linked together by spots of sunlight filtering through the leaves on the trees. The isolated figure in the bottom centre of the picture is reminiscent (but a mirror image) of the prostitute in Cézanne's painting *The Eternal Feminine* (1875–1877, ill. p. 34). Could this also be another memory of the confused sensuality of his early nudes?

The women in all the versions of the *Bathers* are anonymous creatures, with no personality or expression. They are archetypes; their form is more important to the artist than their individuality. Cézanne was primarily interested in the composition as a whole, the harmony between the figures and nature, and between form and colour.

Cézanne painted three large versions of the female bathers, all during the last seven years of his life. The version of *The Large Bathers* in the Philadelphia Museum of Art (1898–1905, ill. p. 89) is the largest, at 208 x 249 cm. This was the first time that Cézanne had painted such a monumental canvas. It was for this painting, which of course was painted in the studio, that Cézanne had a slit built into the wall of his house so that he could also take the painting outdoors and see it in natural daylight (ill. p. 88). The fact that the artist had himself photographed in front of another version of *The Large Bathers* (1900–1905, ill. p. 86), now owned by the

The Large Bathers, 1900–1905
Grandes Baigneuses
Oil on canvas, 130 x 195 cm
Venturi 721; London, The Trustees of the National Gallery

Cover page of the first monograph on Paul Cézanne, written in 1910 by Julius Meier-Graefe, with a drawing by Franz Marc.

A corner of Cézanne's studio on Chemin des Lauves. A partly completed painting stands on the easel, and behind it on the right is the slit in the wall that was constructed for *The Large Bathers*.

Barnes Foundation in Pennsylvania, when it was not yet complete shows how much importance he attached to this painting.

The figures in all three compositions are remarkably simply and coarsely painted. The female creatures frolicking on the riverbank are not graceful; rather they are sturdy, angular, oddly proportioned and plump, and have nothing erotic about them. Cézanne has avoided any suggestion of individuality or temporality and instead has generalized the figures in the same way as the landscapes, so that both have equal artistic weight.

In the Philadelphia version, the atmosphere is created by a light, transparent blue, whose effect is intensified by the complementary orange which is the other main colour. The two colours interact and intensify each other. The blue sky consists of glazing spots of paint which are mainly diagonal. It is made up of a number of layers, partly allowing the light-coloured ground of the painting to show through, and in some places is bound up with the green of the foliage. The blue covers most of the canvas, a turbulent and yet ordered lattice of colour. Superimposed on it is the powerful triangle created by the tree trunks, the figures, the riverbank and the river itself. The trees are bent together, forming a straight-sided arch or protecting roof over the heads of the bathing figures. The riverbank and the river are created using horizontal lines of colour, offsetting the dynamic network of colour and line created by the trees and the figures.

Unlike the watercolour of the female bathers, Cézanne has focused not on the shimmering leaves, but on the trunks which bear the weight of the trees. These create a framework which is both static and dynamic. The figures are also aligned in the same way as the trees; this is probably most apparent in the female figure on the far left, whose upper body and left leg are inclined at exactly the same angle as the tree trunk. However, the contours and arms of the other figures also echo the geometry of the framework.

The women are self-absorbed; they exist only for themselves. In the background, the eye is led to a line of trees and two brightly lit figures on the other side of the riverbank. Only the left-hand of the two figures at the centre of the composition is clearly apparent; it is a man standing with his arms folded looking across the river at the women.

Kurt Badt suggests that this faceless figure is the painter himself; that Cézanne, "beneath the strong, protecting church tower", is looking on at the scene of happiness and harmony from "a distance which can never be bridged".

In the large paintings of bathers, Cézanne has expressed his concept of a new Arcadia, a harmonious unity between man and nature. The painter himself has no part in this harmony. By depicting the figures so crudely, and not making it clear what they are doing, he has stripped them of their individuality and rendered them timeless. They are not being placed on an idealistic pedestal; nor are they everyday, contemporary figures. Rather they are almost abstract beings, re-created for artistic ends, whose incompleteness and lack of clear purpose break with all the cherished myths of nineteenth-century art. They are paving the way for a new form of art in which composition, colour and form predominate, and which follows only its own inherent rules.

"I am working stubbornly; I see the Promised Land before me," wrote Cézanne to the art dealer Ambroise Vollard. "Will my fate be the same as that of the great leader of the Hebrews, or will I be able to enter that land?".

The Barnes Foundation version of *The Large Bathers* (1900–1905, ill. p. 86) is said to have taken five years to paint. This is not the result of any

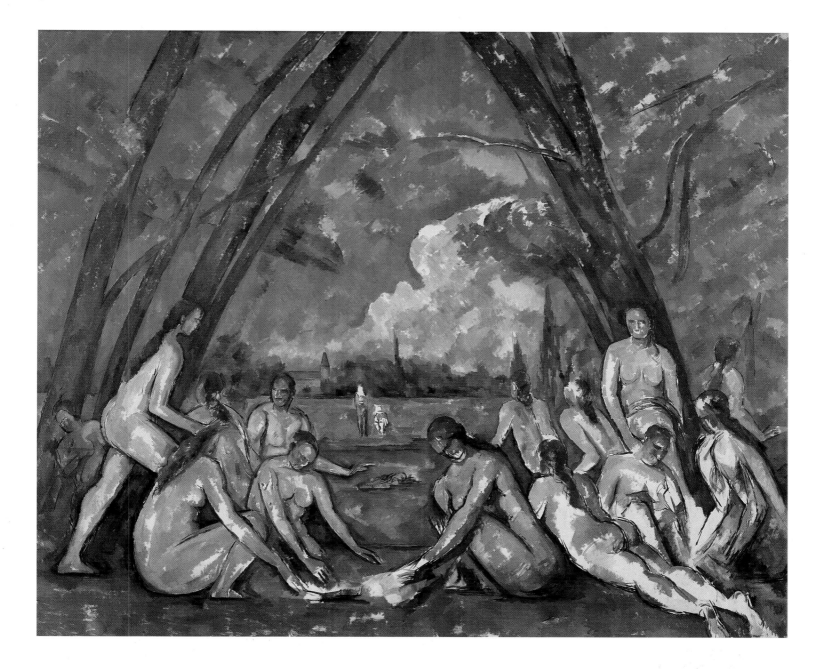

uncertainty in its dating; Cézanne really did spend so long painting it. His extremely slow way of working and dissatisfaction with the results of his efforts led him to leave a number of paintings unfinished. He spent more than a year working on one still life with flowers for Vollard before giving up in discouragement.

Cézanne's health worsened as he grew older. Apart from his diabetes, he also suffered from depression, which was mainly manifested in a growing distrust of his fellow human beings and eventually in paranoia. His mood swayed between euphoria and despair, but he was delighted at the increasingly frequent visits from friends and admirers of his work. He felt that at last he was being taken seriously. In January 1905 he wrote to Roger Marx, the editor of the *Gazette des Beaux-Arts*:

"My age and my health will never allow me to realize the dream of art that I have been pursuing all my life. But I shall always be grateful to the intelligent amateurs who had – despite my own hesitations – the intuition of what I wanted to attempt for the renewal of my art. To my mind, one does not substitute oneself for the past; one merely adds a new link to its

The Large Bathers, 1898–1905
Grandes Baigneuses
Oil on canvas, 208 x 249 cm
Venturi 719; Philadelphia (PA), Philadelphia Museum of Art

Cézanne spent more than seven years working on this painting. The strict triangular composition makes it the most classical of this series. The standing figure on the left is placed at the same angle as the tree trunk. Matisse, who had learned from Cézanne that "a painting gains its power from the tones of colour", used a version of this figure as a model for his 1909 painting, *Bather*.

Bathers, 1900–1906
Baigneuses
Watercolour, 21 x 27 cm
Venturi 1111; private collection

Foliage, c. 1895–1900
Etude de feuillage
Pencil and watercolour, 44.8 x 56.8 cm
Venturi 1128; New York, Museum of
Modern Art, Lillie P. Bliss Collection

The landscape is only vaguely hinted at here.
Cézanne has used vertical brushstrokes to
create space, and has enhanced this effect by
leaving small areas of canvas unpainted.
"What is behind nature?" Cézanne asked
Gasquet. "Nothing perhaps. Perhaps every-
thing. Everything, you understand..."

Bathers Beneath a Bridge, c. 1895
Le pont
Pencil and watercolour, 21 x 27 cm
Venturi 1115; New York, The Metropolitan
Museum of Art

The Bridge of Trois-Sautets, 1906
La rivière au pont des Trois-Sautets
Pencil and watercolour, 21 x 27 cm
Venturi 1076; Cincinnati (OH), Art Museum,
Gift of John Emery

In the hot summer of 1906, Cézanne frequently
went to the banks of the river Arc. Here, in
the shade of the trees, he painted colourful,
semi-abstract watercolours, to which he later
gave added structure using pencil lines.

Cézanne's last letter, asking his paint dealer what has happened to the tubes of paint he ordered.
"Aix, 17 October 1906
Monsieur!
It is now eight days since I asked you to send me ten tubes of burnt lake 7, and I have had no reply. What is the matter?
A reply, and a quick one, I beg of you.
Yours faithfully,
Paul Cézanne"

ILLUSTRATION PAGE 93:
Cézanne at work, c. 1906
Photograph

chain. With the temperament of a painter and an ideal of art – that is to say a conception of nature – sufficient means of expression would have been necessary to be intelligible to the general public and to occupy a decent place in the history of art."

The summer of 1906, Cézanne's last, was unusually hot. Aix was enveloped in a torrid, suffocating heatwave which drove Cézanne almost out of his mind. He had his palette taken to the banks of the river Arc, where it was slightly cooler, and on a small bridge there he painted a number of watercolours, including *The Bridge of Trois-Sautets* (1906, ill. p. 91). The spots of colour representing the foliage are almost abstract. Only the tree trunk, which serves as a *repoussoir*, and the arch of the bridge suggest planes and depth. In some parts of this painting he did something which was rare in his watercolours: he added pencil lines over the spots of paint afterwards to give them a degree of structure. "The main thing is to create as rich a harmony as possible," he wrote to his son in Paris.

The autumn finally brought cooler weather and rain. On 15 October, Cézanne was painting outdoors when he was caught in a huge storm. He was left wet and cold for several hours until he was picked up by a vehicle and taken home, badly weakened. The next morning, he went out into his garden to work on his *Portrait of the Gardener Vallier* (1906), and also wrote an angry letter to his art materials supplier about a delivery of paint (ill. p. 92). But his condition worsened rapidly. His wife and son, who were notified of his illness by telegram, arrived too late. Cézanne died of pneumonia early in the morning of 22 October 1906.

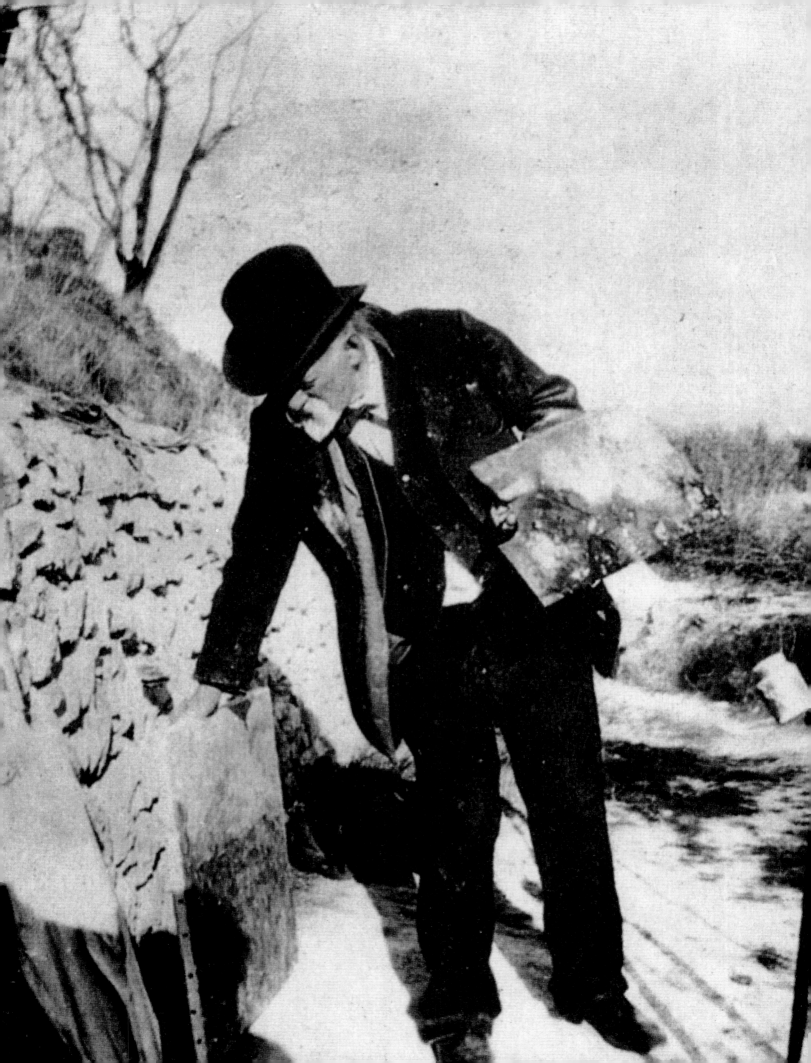

Paul Cézanne – A Chronology

1839 Paul Cézanne is born on 19 January in Aix-en-Provence, the eldest of three children. His father, Louis-Auguste Cézanne, is a dealer and exporter of felt hats in Aix. His mother, Anne-Elisabeth Honorine Aubert, is the daughter of a wood-turner from Marseilles. Paul is baptized in the Sainte-Madeleine church; his parents do not marry until January 1844.

1852 Attends the Collège Bourbon (now Lycée Mignet). Here he befriends Emile Zola, whose father is managing a dam project in Aix, and Jean-Baptiste Baille. The three "Inseparables" make frequent trips into the countryside around Aix.

1859 In accordance with his father's wishes, Paul reluctantly begins a law course at Aix University. He is exempted from military service because his father pays for a substitute. Wins second prize for figure painting at the Ecole spéciale de Dessin. Louis-Auguste Cézanne buys the Jas de Bouffan estate near Aix, the former summer residence of the Governor of Provence.

1861 Spends the period from April to the autumn in Paris and studies life drawing and painting at the Académie Suisse, where he also meets Camille Pissarro. Begins a portrait of Zola, which remains unfinished. In September, returns to Aix in a state of despondency and goes to work for his father's bank. He also attends the drawing school in Aix again.

1862 Sets up a studio at the Jas de Bouffan. Leaves the bank and his legal career and returns to Paris in November. His father pays him an allowance of 125 francs a month.

1863 Regularly works in the Académie Suisse during this and the following year. Here, in addition to Achille Empéraire and Pissarro, Cézanne meets Renoir, Monet and Sisley. His application to the Ecole des Beaux-Arts is rejected on the grounds that, although he has the temperament of a colourist, his paintings are overdone.

1863 Cézanne's work appears along with that of Manet, Pissarro, Jongkind, Guillaumin, Whistler, Fantin-Latour and others in a "Salon des Refusés". Paints wild, demonic, expressive pictures which are described as "flinging paint at the canvas". Regularly visits the Louvre and copies paintings by Delacroix.

1866 Rejected by the Salon, and writes a letter of protest to the Director of Fine Arts. Meets Manet, who praises his still lifes. First experiments with open-air painting. Goes to Aix from August onwards, where he paints a portrait of his father reading the newspaper.

1869 Rejected by the Salon again. Meets Hortense Fiquet, a 19-year-old bookbinder.

Paul Cézanne, c. 1861
Photograph

Paul Cézanne, c. 1875
Photograph

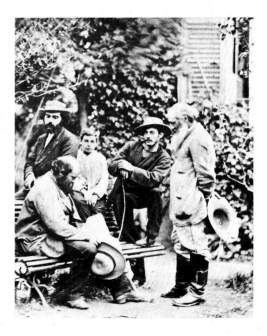

Cézanne (seated) with Camille Pissarro in Pontoise, c. 1877, Photograph

**Paul Cézanne, c. 1889/1890
Photograph**

Cézanne at work *sur le motif* in Aix-en-Provence, c. 1906, Photograph

Talking to the artist Gaston Bernheim de Villers, 1906, Photograph

1870–1871 Rejected by the Salon. Spends the period of the Franco-Prussian War with Hortense in L'Estaque. End of his dark, expressive, intuitive period. Returns to Paris after the Commune is declared.

1872 Cézanne's son Paul is born. The family moves to Auvers-sur-Oise, where Cézanne works closely with Pissarro.

1873 Befriends Dr Gachet, in whose house he paints. Meets the paint dealer Julien Tanguy and exchanges paint for pictures. Meets Van Gogh at Tanguy's house.

1874 First group exhibition by the Impressionists at the studio of the photographer Nadar. Cézanne's paintings (*The House of the Hanged Man at Auvers, Landscape, Auvers, A Modern Olympia*) attract considerable attention. Spends the summer in Aix and returns to Paris in September.

1875 Rejected by the Salon. Through Renoir, meets the customs inspector and art-lover Victor Chocquet, who becomes one of the most enthusiastic collectors of his work.

1877 Shows sixteen paintings at the third Impressionist exhibition and again provokes a hail of criticism.

1878 Spends the year in Aix and L'Estaque, while Hortense and their young son live in Marseilles. Cézanne's father learns of the family's existence and cuts Cézanne's monthly allowance. Zola helps him with his money problems. Rejected by the Salon.

1879 Rejected by the Salon. In August, visits Zola in Médan, but is alienated by his luxurious lifestyle.

1885 Rejected by the Salon again and decides not to enter any more pictures. Spends this and subsequent years mainly in Aix and the surrounding area.

1886 Breaks off friendship with Zola after publication of *L'Œuvre*, Zola's novel about a failed artist. Marries Hortense Fiquet. Cézanne's father dies in August, and he inherits a considerable fortune.

1887 Spent mainly in Aix. Paints with Renoir at the Jas de Bouffan.

1890 Shows three paintings at the "Les Vingt" exhibition in Brussels. In summer, spends five months with his family in Switzerland. Returns to Aix in autumn. Found to have diabetes.

1895 First one-man exhibition in December at the gallery of the Paris art dealer Ambroise Vollard.

1896 Paints in Bibémus quarry. Meets the writer Joachim Gasquet.

1897 Spends most of his time in Aix. Mother dies in October. The Nationalgalerie in Berlin is the first gallery to buy one of his paintings.

1898 Works in Aix, in the area and around the Château Noir. Later spends one last long period in Paris.

1899 Remains in Paris until the autumn, and then returns to Aix, where he remains almost continuously for five years. Jas de Bouffan sold. Cézanne buys a small apartment in the town of Aix and takes on a housekeeper. His wife and son mainly live in Paris. Another one-man exhibition held at Vollard gallery; his paintings fetch significant prices.

1900 Three of his paintings shown at the Century Exhibition in Paris. The art dealer Cassirer organizes a one-man exhibition in Berlin, but not one of his paintings is sold.

1901 Takes part in the Salon des Indépendants in Paris and also in exhibitions in Brussels and The Hague. Buys a plot of land on Chemin des Lauves, overlooking Aix.

1902 Moves into his studio house on Chemin des Lauves. Zola dies in September.

1903 When Zola's collection of paintings is auctioned, the works by Cézanne fetch an average of 1,500 francs. Takes part in the Vienna Secession exhibition. Pissarro dies.

1904 Emile Bernard visits Cézanne in Paris and watches him working. Travels to Paris for the Autumn Salon, where thirty of his paintings are on display. Second exhibition at Cassirer's in Berlin. Becomes increasingly reclusive and is weakened by his diabetes.

1905 Exhibits at the autumn Salon and the Salon des Indépendants. The art dealer Durand-Ruel sends ten of his paintings to the Impressionists exhibition in London.

1906 Takes part in the autumn Salon. Also in the autumn, Cézanne is caught in a storm while painting and dies of pneumonia shortly afterwards, on 22 October. Buried at the St Pierre cemetery in Aix.

1907 Major retrospective of Cézanne's work at the Autumn Salon, featuring fifty-six of his paintings.

1954 Cézanne's studio house on Chemin des Lauves is opened to the public.

Dr Ulrike Becks-Malorny
(born 1950)
Studied free painting in Geneva and art history in Bochum, Germany. Since gaining her doctorate in 1990, she has worked as an exhibition organizer and freelance author.

Picture credits
The publishers are grateful to the galleries, archives and photographers involved for granting reproduction rights and for their help and support in producing this book. The following credits apply in addition to those already mentioned in the picture captions:
Archiv für Kunst und Geschichte, Berlin: 10, 11, 23, 42, 51, 54, 61, 63, 69, 87
Artothek, Peissenberg: 21, 46 (Jochen Remmer), 49 (Josef S. Martin), 70 (Alexander Koch), 79 (Joachim Blauel)
Bildarchiv Preussischer Kulturbesitz, Berlin: 25, 65, 72, 83 (Alexander Burkatovski)
Bridgeman Art Library, London: 13, 14, 17 (Lauros-Giraudon/Bridgeman Art Library), 29, 57 (Giraudon/Bridgeman Art Library), 60, 61 (Lauros-Giraudon/Bridgeman Art Library), 64 (Giraudon/Bridgeman Art Library), 71
Martin Bühler, Basle: 75
Christie's Images, London: 62
Ute Edelmann, Hamburg: 22
Giraudon, Paris: 32
Luiz Hossaka, São Paulo: 44
The Museum of Modern Art, New York, Photograph © 1995: 80, 81, 90
Réunion des Musées Nationaux, Paris: 30, 35, 45.

In this series:

- Arcimboldo
- Bosch
- Botticelli
- Bruegel
- Cézanne
- Chagall
- Christo
- Dalí
- Degas
- Delaunay
- Duchamp
- Ernst
- Gauguin
- van Gogh
- Grosz
- Hopper
- Kahlo
- Kandinsky
- Klee
- Klein
- Klimt
- Lempicka
- Lichtenstein
- Macke
- Magritte
- Marc
- Matisse
- Miró
- Monet
- Mondrian
- Munch
- O'Keeffe
- Picasso
- Rembrandt
- Renoir
- Rousseau
- Schiele
- von Stuck
- Toulouse-Lautrec
- Turner
- Vermeer
- Warhol